UNIVERSITY OF
NORTH CAROLINA
FOOTBALL

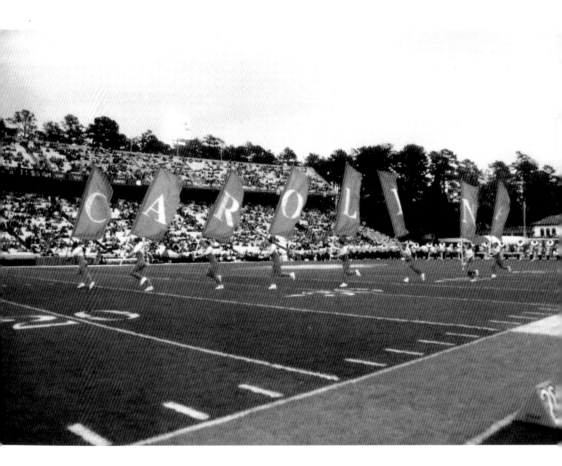

IN THIS IMAGE, TAKEN PRIOR to a 2001 game in Chapel Hill's Kenan Stadium, a group of University of North Carolina (UNC) cheerleaders prepare to lead the Tar Heels onto the field with the familiar word CAROLINA spread out over a series of banners. The Tar Heels have called Kenan Stadium home since 1927, and the venue has been host to some memorable scenes over the years. Two of the more famous moments in the history of Kenan Stadium have come in recent times, as the Tar Heels upset heavily favored Florida State 41-9 on September 22, 2001, and defeated the University of Miami 31-28 on October 30, 2004.

ON THE COVER: In this image, taken for the 1947 edition of the *Yackety Yack* by photographer Hugh Morton, Charlie "Choo Choo" Justice laces up his cleats for practice. Justice was the greatest football player to ever play at the University of North Carolina, leading the school to two Southern Conference championships, two Sugar Bowl appearances, and a Cotton Bowl appearance in a career spanning from 1946 to 1949. He was named first-team All-Southern Conference and an Associated Press All-American in each of the four years he played at North Carolina, and he is a member of the College Football Hall of Fame. (Courtesy of the *Yackety Yack* Yearbook.)

UNIVERSITY OF NORTH CAROLINA FOOTBALL

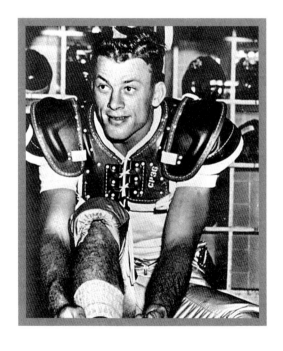

Adam Powell

ARCADIA
PUBLISHING

Published by Arcadia Publishing
Charleston SC, Chicago IL, Portsmouth NH, San Francisco CA

Printed in the United States of America

Library of Congress Catalog Card Number: 2006923854

For all general information contact Arcadia Publishing at:
Telephone 843-853-2070
Fax 843-853-0044
E-mail sales@arcadiapublishing.com
For customer service and orders:
Toll-Free 1-888-313-2665

Visit us on the Internet at www.arcadiapublishing.com

This book is dedicated to the memories of the former coaches and players

of the University of North Carolina football team that are deceased.

May your legacies endure for many years to come.

CONTENTS

ACKNOWLEDGMENTS

It has been a thrill for me to create this book, which enabled me to learn a great deal more about my alma mater's football history. Completing this project was far from a solo effort, and with that in mind, I wish to offer a big thank-you to Kevin Best, of the University of North Carolina's Athletic Communications Office, and Lauren Scott, the editor of the *Yackety Yack*, the university's yearbook. Kevin and Lauren assisted tremendously in acquiring photographs for this project, and I thank each of them for their time and their willingness to help me. I also wish to thank authors Ken Rappoport and Tom Perrin, whose books contributed heavily to my research, and the College Football Data Warehouse Web site, (www.cfbdatawarehouse.com), an outstanding source of pertinent statistical information for the captions located throughout the pages of this book.

In addition, I wish to offer my thanks to Aaron Garrish, for the use of his photograph scanning equipment, and to my roommates, Rick Pawliczek and Steve Ellis, for their helpfulness and rides to campus for research and materials. Also I want to thank my girlfriend, Julie Stuman, for her patience, her attentiveness, and her love. I love you, too! I also wish to acknowledge six of the most important people in my life; my parents, Orlando and Debbie Powell, my two grandmothers, Georgia Powell and Katie Harrelson, my aunt, Daisy Potzman, and my cousin Ruth Ann "Rusty" Southerland, a brave and inspiring woman.

Author's Note: All images in this book, unless otherwise noted, are courtesy of the University of North Carolina's Athletic Communications Office or the UNC–Chapel Hill yearbook, the *Yackety Yack*.

INTRODUCTION

The University of North Carolina at Chapel Hill (UNC) was among the first schools in the South to embrace the sport of football, which was introduced on college campuses shortly after the Civil War. In 1888, a group of UNC students formed a team. During that fall, and then in the spring of 1889, they agreed with Trinity College, which later became Duke University, and Wake Forest College to play a series of games in Raleigh. These were the first known intercollegiate football contests played in North Carolina. The school was highly successful on the gridiron in its formative years, posting winning records six times from 1892 to 1899, including a perfect 9-0 season in 1898. The team continued to find success after 1900, stretching its streak of consecutive winning seasons to nine straight years in 1905. After a few seasons of mediocrity, the program returned to form in 1909, going 5-2, and in 1911, when the Tar Heels finished 6-1-1 under Branch Bocock. Coaches Thomas Gawthrop "Doggie" Trenchard and Thomas Campbell helped UNC remain among the strongest football teams in the South in the years prior to World War I, enjoying four straight winning seasons from 1913 to 1916. The outstanding 1914 team finished 10-1, which stood as the school's best season in terms of victories for more than 50 years.

Following World War I, brothers Bob and Bill Fetzer helped the team continue its gridiron success. The Tar Heels posted a 9-1 record in 1922 and added a 7-1-1 season in 1925. The Fetzers eventually handed the coaching job over to Chuck Collins, who was at UNC from 1926 to 1933. Collins had three winning seasons, including a 9-1 season in 1929, before being replaced by Carl Snavely. Snavely led UNC to a 7-1-1 season in 1934, and the coach who would become known as the "Grey Fox" returned to lead the team to an 8-1 mark in 1935. UNC president Frank Porter Graham, a zealous educator, attempted to de-emphasize football at the university during this period, which compelled Snavely to leave after the 1935 season. The new coach, Raymond "Bear" Wolf, brought an exciting style of football to Chapel Hill in 1936, and he soon became a beloved figure. The Wolf years were very fruitful for the Tar Heels, as the team produced five straight winning seasons from 1936 to 1940. Wolf went into the navy after the 1941 season, and for the next few years, multiple men led the team, including former star tackle Jim Tatum.

In 1945, however, Snavely returned to Chapel Hill, where he led the greatest era of football in the history of the school. With more leeway to recruit and the benefit of athletes returning from military service after the 1945 season, Snavely assembled a team that grabbed national headlines and rubbed elbows with the elite of college football. Coaching such All-Americans as Charlie "Choo Choo" Justice, Ken Powell, Art Weiner, and Len Szafaryn, Snavely guided North Carolina to two Southern Conference titles and a record of 32-9-2 from 1946 to 1949. Behind the play of Justice, a two-time runner-up to the Heisman Trophy whose name defined the era, the Tar Heels appeared in the 1947 and 1949 Sugar Bowls, along with the 1950 Cotton Bowl.

Snavely struggled to keep Carolina at the top of the Southern Conference after the Justice era, and in 1953, he was replaced by one of his former players, George Barclay. Barclay oversaw UNC's acclimation into the Atlantic Coast Conference (ACC) in the mid-1950s, but following the 1955 season, a former teammate, Jim Tatum, returned to Chapel Hill for his second stint as head coach of his alma mater. Tatum had become one of the finest coaches in America at Maryland, where he had led the Terrapins to five bowls, two undefeated seasons, and a national championship. Tatum took over a Tar Heel program low on morale, but he quickly whipped it into form, ending seven years of losing during his second season of 1957, when he guided Carolina to a 6-4 mark. The Tar Heels finished 6-4 again in 1958 and were on the brink of becoming a national power when tragedy struck. In July 1959, Tatum passed away after contracting a rare illness. The university was overwhelmed with shock and sadness over Tatum's death and what might have been in regards to the future of the football program.

One of Tatum's assistants, Jim Hickey, took over for the fall of 1959 and wound up staying in Chapel Hill for seven years. The Tar Heels had three seasons with 5-5 records in the Hickey years and a single winning season: the 1963 squad that shared the school's first ACC title and defeated Air Force in the Gator Bowl. Despite a number of talented players, the Tar Heels were unable to post another winning season until Bill Dooley brought a fresh and energetic approach to Chapel Hill. Utilizing a running game that featured numerous 1,000-yard rushers over the years, Dooley led UNC to back-to-back ACC titles in 1971 and 1972 and another league championship in 1977. The 1972 team posted a school-record 11 victories, including a Sun Bowl victory over Texas Tech. Dooley left Chapel Hill in 1977 and was replaced by Dick Crum. Crum, who would become the most victorious coach in school history, won four consecutive bowl games from 1979 to 1982, along with an ACC title in 1980. Unfortunately only one winning record over a period of four seasons resulted in the buyout of Crum's contract following the 1987 season.

Mack Brown, a relative unknown in coaching at the time, guided Carolina to 1-10 records in both 1988 and 1989, but by 1990, he had things decisively turned around. Starting in 1990, Brown led North Carolina to winning seasons for eight straight years, including a period from 1992 to 1997 in which the team went to six consecutive bowl games, winning four, and posted an overall record of 54 wins against only 18 losses. Following one of the most successful regular seasons in school history, a 10-1 mark in 1997, Brown left UNC to take the head coaching job at Texas. Defensive coordinator Carl Torbush came aboard and led Carolina to a decisive 42-3 victory in the 1998 Gator Bowl, and he became head coach for the next three seasons. Following the 2000 season, Torbush was replaced by former Tar Heel linebacker John Bunting, who has led the program to two bowl appearances in his five seasons as head coach. Bunting hopes to continue North Carolina's tradition of gridiron competitiveness well into the future.

THE EARLY YEARS

1 8 8 8 — 1 9 2 0

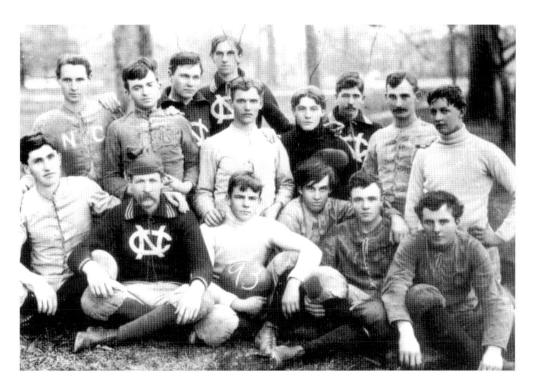

IN THIS IMAGE, ONE OF the earliest known of a University of North Carolina football team, the 1893 squad assembles for a group photograph. The 1893 team played an ambitious schedule of seven games, and although the Tar Heels finished with a losing record of 3-4, they were dominant in their three victories. UNC manhandled Washington and Lee 40-0 in the season opener in Lexington and demolished Tennessee 60-0 in Chapel Hill in early November. The team's final victory, a 40-0 verdict over Wake Forest in Raleigh, was played 11 days later. Although the Tar Heels lost to Lehigh University in a game played in New York City on November 25, the *New York World* reported, "If these Southern men had any scientific knowledge of the game, they would have easily beaten Lehigh. All their gains were made by sheer force and brute strength." Among the members of this particular team was letterman William Rand Kenan, the primary benefactor of Kenan Stadium.

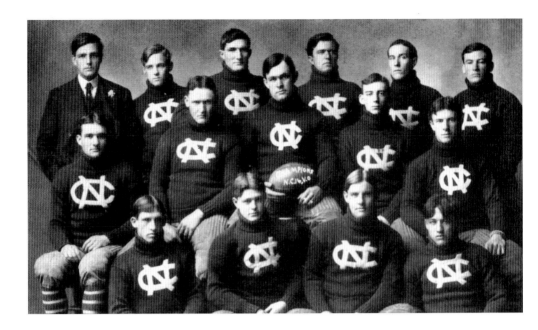

THE 1903 TEAM, UNDER THE leadership of Herman Olcott, finished with a record of six wins and three losses. The Tar Heels opened with four straight victories, and following three defeats, they knocked off Clemson 11-6 in Chapel Hill. Most importantly, the Tar Heels went to Richmond and shut out Virginia 16-0.

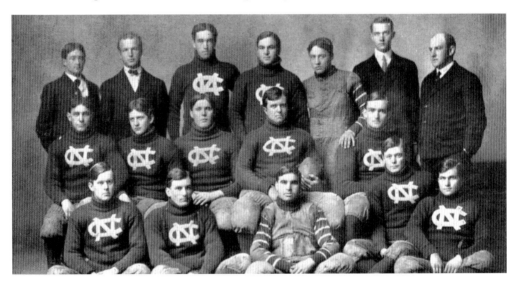

THE 1904 TEAM WAS SUPERB ON DEFENSE, especially early in the year. The Tar Heels shut out each of their first six opponents to start the season with a 5-0-1 record. Things got a little tougher in November, as UNC lost to Georgetown and Virginia and played North Carolina State to a 6-6 tie. The setbacks to Georgetown and Virginia gave Carolina a final record of 5-2-2.

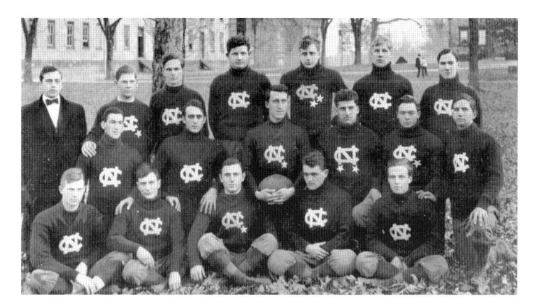

THE 1909 TAR HEELS POSTED Carolina's first winning record in four years, with a 5-2 mark. In each of the team's five victories, which came over Wake Forest, Tennessee, Georgetown, Richmond, and Washington and Lee, the Tar Heels shut out the opposition.

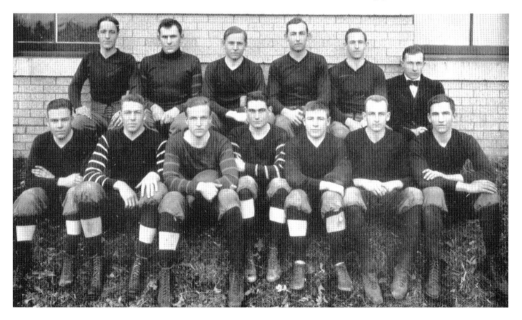

THE 1911 TEAM GOT OFF to a fantastic start, winning six of its first seven games, while allowing only three total points over the stretch. Unfortunately the Tar Heels were unable to complete the season unbeaten, as they were outplayed by Virginia 28-0 in Richmond. Despite the setback to UVA, the 6-1-1 record was the best winning percentage for a Carolina team thus far in the 20th century.

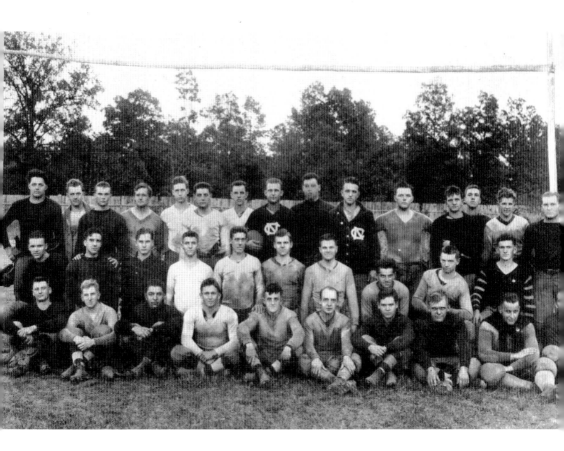

THE 1914 TAR HEELS, UNDER the guidance of head coach Thomas Gawthrop "Doggie" Trenchard, finished with 10 victories, the school's highest win total to that time. The team was an offensive juggernaut, winning its first six games by scores of 41-0, 65-0, 53-0, 48-0, 41-6, and 40-0. For the year, the Tar Heels outscored their opposition by a grand total of 359 to 52. Although Carolina squeaked by Vanderbilt 10-9 in its seventh game, the team went on to beat Davidson, Virginia Military Institute, and Wake Forest in the following weeks. The Tar Heels took a perfect 10-0 record heading into its season finale against Virginia, but they were snakebitten once again by their nemesis from Charlottesville, as Virginia defeated them for the seventh straight time, 20-3. Despite the bitter loss to Virginia, it would be another 58 years before a Carolina football team again reached 10 victories in a single season.

THE EARLY YEARS

AFTER POSTING A COMBINED RECORD of 17-5-1 in his first three seasons of coaching, Branch Bocock came to UNC in 1911 and led the Tar Heels to a 6-1-1 record. It would be Bocock's only season at Carolina, as he returned to Virginia Tech in 1912. In an 18-year coaching career that spanned four decades and included additional stops at Louisiana State and South Carolina, Bocock won 98 games.

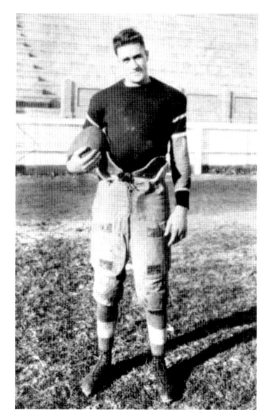

BILL FOLGER COMPLETED ONE OF the most significant individual plays in the early days of the Carolina football program, running for a 52-yard touchdown against Virginia in 1916. The run was the only touchdown scored in front of 15,000 fans on a damp, slippery field in Richmond, as Carolina celebrated a 7-0 victory, the school's first triumph over the Cavaliers since 1905.

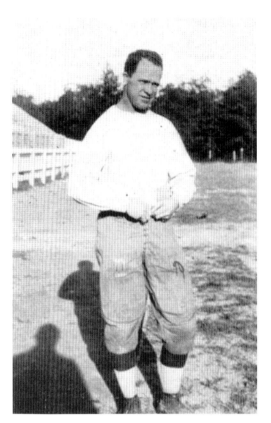

THOMAS CAMPBELL COACHED THE UNC varsity in 1916 and 1919, leading the team in the years before and immediately following the involvement of the United States in World War I. The university did not host a varsity team in 1917 and 1918. The Tar Heels were a respectable side during the Campbell years, posting winning records during both his seasons as coach. Campbell left Carolina after the 1919 season.

WITH THE UNITED STATES ENGAGED IN World War I during the fall of 1917, the university elected not to field a varsity football team, but that did not stop a large number of students from participating on the UNC junior varsity team, pictured here. The identities of these players are unknown; there was no official coach.

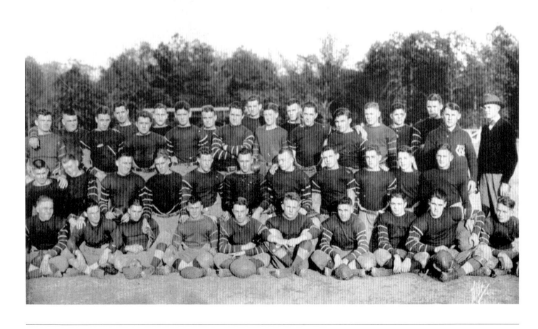

THE EARLY YEARS

THE FETZER BROTHERS AND CHUCK COLLINS YEARS

1921–1935

ROBERT A. "BOB" FETZER, THE longtime athletic director and track coach at UNC–Chapel Hill, coached the Tar Heel football team, along with his brother Bill, from 1921 to 1925. The Tar Heels were a solid outfit under the Fetzer brothers, posting winning seasons in four of the five years they led the team, including a 9-1-1 record in 1922 and a 7-1-1 mark in 1925. The 1922 team claimed the South Atlantic championship and a share of the newly formed Southern Intercollegiate Association title, the predecessor to the Southern Conference. Despite a number of injuries to members of the 1925 squad, they admirably won the state championship. The Virginia game that season, which resulted in a 3-3 tie, drew an overflowing crowd of more than 16,000 fans to Chapel Hill's Emerson Field, which held less than 2,500 seats. That game helped ignite the motivation to build what would eventually become Kenan Stadium. Today a gymnasium in the heart of the UNC campus is named in Fetzer's memory.

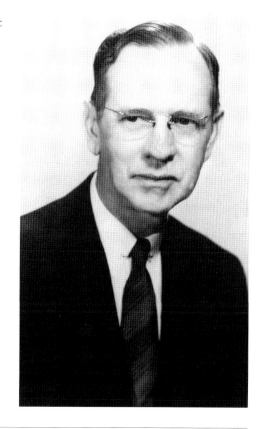

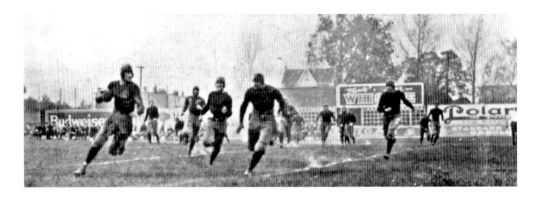

In this image, UNC's Johnny Johnson runs with the ball during a game against the University of Maryland in Baltimore on October 29, 1921. Thanks to runs such as this, the Tar Heels prevailed on this day, claiming a 16-7 victory.

The 1925 Tar Heels, the last coached by the Fetzer brothers, suffered a 6-0 loss to Wake Forest in their season opener, which turned out to be the team's only defeat. The Tar Heels shut out their next five opponents and, following a sixth straight win, knocked off Davidson 13-0 to claim the state championship. UNC concluded with a tie against Virginia, giving the team a final record of 7-1-1.

CHUCK COLLINS COACHED AT CAROLINA from 1926 to 1933. The Tar Heels struggled in his first two years but enjoyed winning seasons from 1928 to 1930. The 1929 season, in which Carolina finished 9-1, was the highlight of the Collins years, for after finishing 5-3-2 in 1930, the Tar Heels were 11-13-5 from 1931 to 1933, which included back-to-back losing seasons. Collins was replaced following the 1933 season.

THIS PHOTOGRAPH WAS TAKEN DURING THE annual Carolina-Virginia football game on November 29, 1929. In the midst of Chuck Collins's best year at UNC, the Tar Heels, the team in stripes in this image, breezed past the Cavaliers, claiming a 41-7 victory in Chapel Hill. A week later, the Tar Heels handed Duke a similar beating, 48-7, to finish the season on a six-game winning streak.

THE 1929 TAR HEELS FINISHED with an overall record of 9-1. After shutting out Wake Forest and Maryland in the season openers, UNC defeated Georgia Tech for the first time in school history. Following a 19-12 defeat to Georgia in their only loss of the season, the Tar Heels finished with six straight victories, including triumphs over in-state rivals NC State, Davidson, and Duke, while averaging 37.5 points an outing.

JOHNNY BRANCH HAD FIVE PUNT returns of 60 or more yards during his career at UNC, including one he returned 85 yards for a touchdown against Virginia Tech in 1930. He followed it up the next week with a 96-yard return against Maryland, which still ranks as the longest in UNC history.

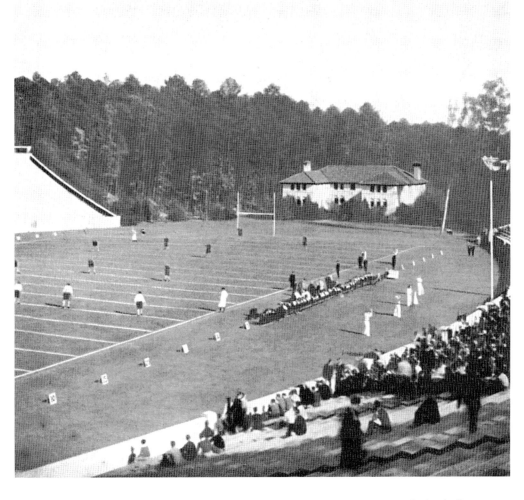

KENAN STADIUM WAS BUILT ON LAND ADJACENT to the University of North Carolina's classroom buildings and Wilson Library. Financed by former letterman William Rand Kenan, who wished to create a memorial for his parents, the venue hosted its first Tar Heels game on November 12, 1927; UNC defeated Davidson 27-0. This illustration, which was created for the 1933 edition of the *Yackety Yack*, captures the scene just prior to kickoff of the Carolina–Georgia Tech football game in Kenan on October 22, 1932. Although Chuck Collins's Tar Heels were soundly defeated on this day by Bill Alexander's Ramblin' Wreck, the illustration depicts, in remarkable detail, the east end zone, including the venerable old Field House, which stands to the present day. The illustration also reflects a largely empty stadium, which was not uncommon during the Great Depression years.

JIM TATUM, SEEN HERE DEFLECTING a punt against Wake Forest in 1933, was one of the fiercest competitors to ever play at Carolina.

One of Tatum's most significant plays as a Tar Heel was another blocked punt, which came against Duke in a 7-0 UNC victory in 1934.

IN THIS IMAGE, NEW COACH CARL Snavely (left) and captain George Barclay shake hands prior to the 1934 season. Snavely found immediate success at Carolina, posting an overall record of 15-2-1 in 1934 and 1935, but thanks to the athletic de-emphasizing policies of then-UNC president Frank Porter Graham, he decided to leave after only two years. Barclay, an outstanding blocker and tackler, became North Carolina's first All-American in 1934.

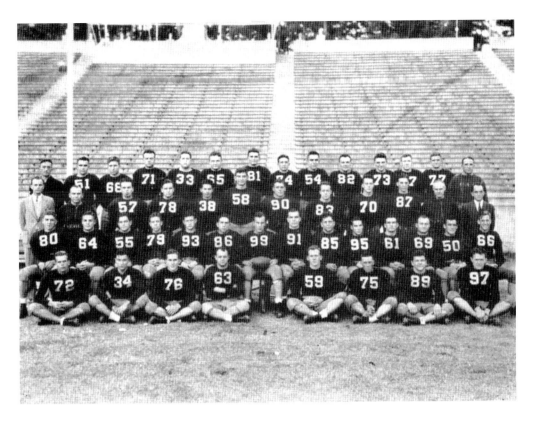

CARL SNAVELY'S FIRST CAROLINA TEAM OF 1934 exceeded expectations, posting a record of 7-1-1. An outstanding defense, which surrendered only 34 points all season, allowed an average of just 105 yards of total offense per game, a school record that has stood for more than 70 years. The Tar Heels were unbeaten over their final seven games, which included shutouts over Georgia, Kentucky, Georgia Tech, and Duke.

THE 1935 CAROLINA SQUAD STARTED off well, winning its first seven games and posting shutouts over five opponents. There was talk of a possible Rose Bowl berth until the Tar Heels faced a tough Duke team that beat them 25-0 in Durham. Angered over the loss to the Blue Devils, the Tar Heels embarrassed Virginia 61-0 in the season finale to finish the year with an 8-1 record.

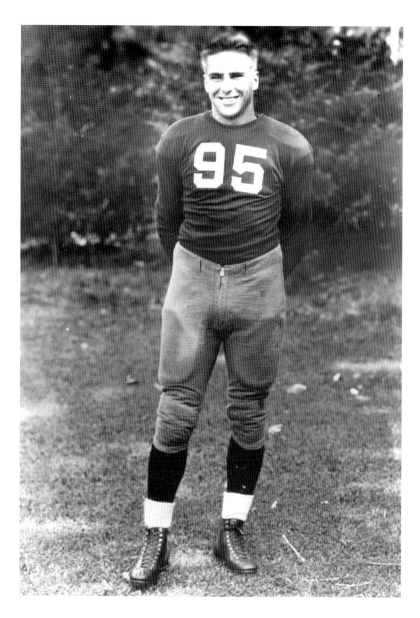

DON JACKSON DID A LITTLE BIT of everything during his football career at Carolina, helping the team experience a resurgence in the mid-1930s. A three-year letter winner from 1933 to 1935 who played under coaches Chuck Collins and Carl Snavely, Jackson led the Tar Heels in total offense and all-purpose yardage during both the 1934 and 1935 seasons, helping the team win 15 games against just 2 defeats those years. A two-way player, Jackson played in both the offensive and defensive backfields for Carolina, along with serving on special teams, and in 1935, he led the team in passing yardage, rushing yardage, passing touchdowns, rushing touchdowns, punting, kickoff return yardage, punt return yardage, and interceptions. As a result of his impressive season, Jackson was named first-team All-Southern Conference and a second-team All-American by the Associated Press.

3

THE BEAR YEARS AND
WORLD WAR II

1936–1945

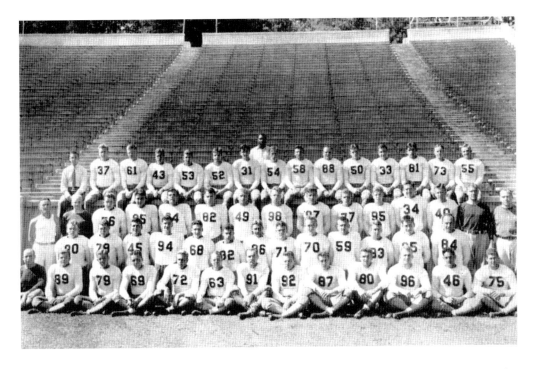

RAYMOND "BEAR" WOLF, A SUCCESSFUL LINE coach at Texas Christian University, came to Chapel Hill in 1936 to become head coach at North Carolina. Wolf negated popular Southern football theory of the time, employing an offense that liberally utilized the forward pass, and he found immediate success with his first Tar Heel team of 1936, leading UNC to an 8-2 record that fall. The Tar Heels won the first four games of the season, including a hard-fought 14-13 victory over New York University in Yankee Stadium on October 17. Following a 21-7 loss the following week to Tulane in sweltering New Orleans, the Tar Heels won four of their final five contests, including wins over NC State, Davidson, South Carolina, and Virginia.

"BEAR" WOLF COACHED AT NORTH Carolina from 1936 to 1941, where he enjoyed five winning seasons and became a beloved figure. Wolf led the Tar Heels to the 1937 Southern Conference title with a 7-1-1 overall record, and he added an 8-1 finish in 1939. Wolf left UNC to join the navy following the 1941 season, after posting an overall record of 38-17-3 in six seasons as head coach.

DICK BUCK LED THE TAR HEELS in receiving in 1934 and 1936. In 1934, Buck caught three touchdown passes, including a 12-yard strike from Don Jackson in UNC's 7-0 victory over Duke. Buck helped Carolina's offense make the transition from Snavely's conservative approach to Wolf's wide-open style in 1936, and that season, Buck caught 20 passes, which established a new school record.

THE BEAR YEARS AND WORLD WAR II

ANDY BERSHAK WAS AN OUTSTANDING two-sport athlete at Carolina in the mid 1930s, helping the Tar Heels win Southern Conference (SC) titles in both football and basketball. A two-time selection to the SC's first team in football, Bershak led UNC in receiving in 1937, and following the season, he was named a consensus All-American.

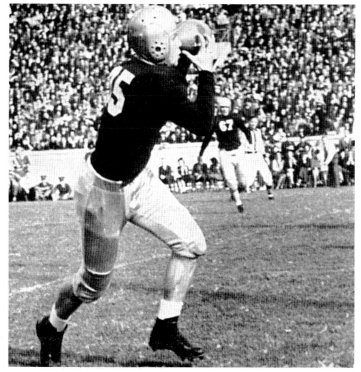

IN THIS PHOTOGRAPH, George Watson catches a pass and prepares to take off during a game against NC State in Kenan Stadium on October 1, 1938. With help from Watson, the Tar Heels prevailed over the Wolfpack 21-0. Watson led Carolina with seven touchdowns in 1937 and in kickoff return average and interceptions in 1938.

STEVE MARONIC RARELY CAME OFF the field during his time at Carolina, serving as a tackle and place kicker. A cocaptain in 1938, Maronic was named first-team All-American and All Southern Conference in helping the Tar Heels post a 6-2-1 record.

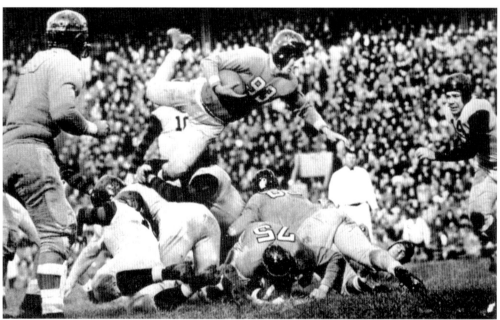

IN THIS IMAGE, TAKEN DURING Carolina's 30-6 victory over the University of Pennsylvania on October 28, 1939, quarterback Jim Lalanne (number 93) dives for extra yardage. Trailing 6-0 at halftime, Lalanne led a second-half offensive explosion, throwing three touchdowns and adding a fourth on the ground in less than half a quarter of play. Lalanne led Carolina in passing and total offense for three consecutive seasons from 1938 to 1940.

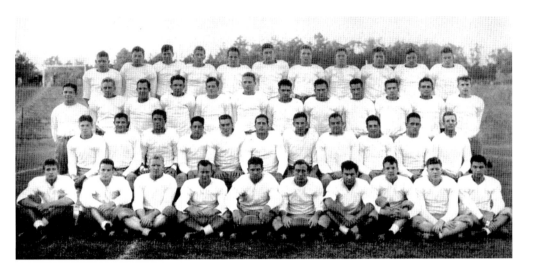

THE 1939 TAR HEELS HAD a "Never Say Die" spirit, which aided second-half rallies to beat New York University and Penn. The Tar Heels took a 7-0-1 record into the Duke game, but they were unable to stay unbeaten. The Tar Heels shut out Virginia to finish 8-1-1.

GEORGE RADMAN EARNED three letters at Carolina from 1937 to 1939, playing on Tar Heel teams that combined to produce an impressive record of 21 wins, 4 losses, and 3 ties. Radman, like most players of the era, played offense and defense, and in 1937, he led the Tar Heels with four interceptions. A year later, he paced the team with six touchdowns.

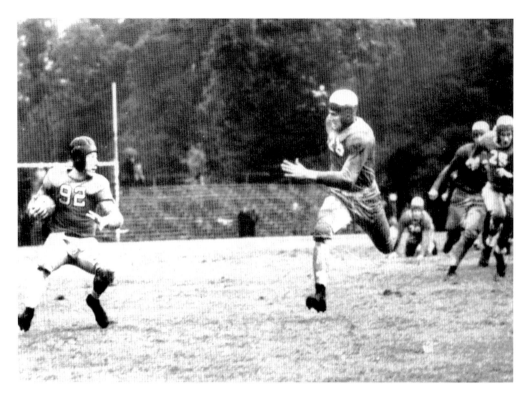

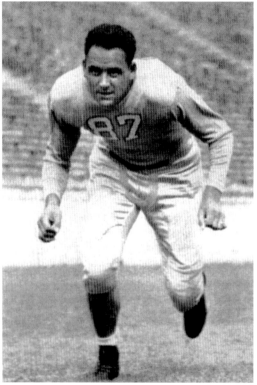

IN THIS ACTION PHOTOGRAPH FROM 1939, George Stirnweiss (number 92) attempts to pull up and avoid an oncoming defender. Stirnweiss was a varsity football player at Carolina from 1937 to 1939, and he served as cocaptain on the 1939 team that reached the Top 10. Following the season, he was named first-team All-Southern Conference as a back and a second-team All-American by the Central Press.

PAUL SEVERIN WAS NAMED TO THE ALL-Southern Conference and All-American teams following both the 1939 and 1940 seasons. Among his more memorable efforts was a touchdown to salvage a 14-14 tie with Tulane in 1939 and a game-saving tackle against Duke in 1940, in which Severin got up after falling down and caught Blue Devil standout Steve Lach from behind to preserve a 6-3 Carolina victory.

THE BEAR YEARS AND WORLD WAR II

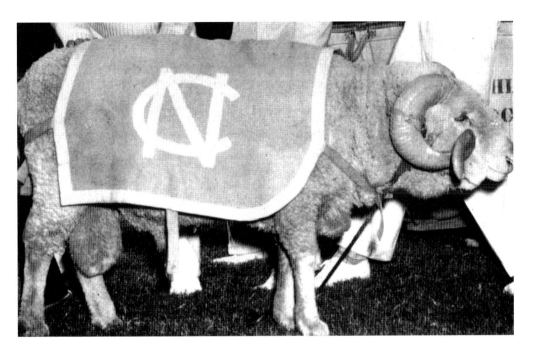

IN THIS IMAGE, THE UNIVERSITY of North Carolina's mascot, Rameses, is seen prior to a 1941 game. The symbolic ram became a beloved figure on the Tar Heel campus starting in 1924 when, according to legend, Bunn Hackney rubbed the animal's head for good luck prior to nailing a 30-yard dropkick to give Carolina a 3-0 victory over VMI. Ever since, Rameses has been a fixture on the UNC sidelines.

IN THIS PHOTOGRAPH, THE UNC–CHAPEL Hill Marching Band prepares to take the field during halftime of a 1942 game in Kenan Stadium. With World War II in full swing, it was a patriotic time, as evident by the American flag leading the musicians onto the field. The wooded area behind the end zone provides a stark contrast to the present day, with seats having enclosed the entire area.

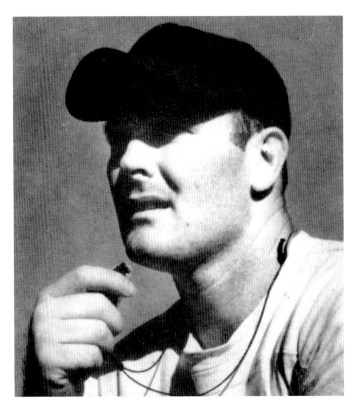

FOLLOWING THE END of his playing career at Carolina, Jim Tatum was lured into coaching by his mentor, Carl Snavely. After following Snavely to Cornell in 1936, Tatum returned to Chapel Hill in 1939 to lead the freshmen. Within three years, Tatum was guiding the UNC varsity. Tatum led Carolina to a 5-2-2 record in 1942, which included wins over rivals Wake Forest, South Carolina, and Davidson.

BILLY MYERS WAS A GOOD player on Carolina's teams of the World War II years, which experienced quite a bit of turnaround. With players and coaches coming and going due to the circumstances of the war, Myers was a rare three-year letter winner, leading the team in rushing, passing, scoring, and total offense in 1942, and pacing the Tar Heels in passing, scoring, and interceptions in 1943.

THE JUSTICE ERA

1946–1949

THE INCOMPARABLE CHARLIE "CHOO Choo" Justice takes the field prior to a game during his senior season of 1949. Recruited to Chapel Hill following World War II, Justice had taken the South by storm during his rookie year in 1946, returning both a kickoff and a punt for touchdowns in a 40-19 victory over Florida and producing 1,557 all-purpose yards in leading Carolina to an 8-1-1 regular season record and a trip to the 1947 Sugar Bowl. Although his rushing numbers declined after 1946, Justice continued to be a lethal return man, running back a punt 84 yards for a touchdown in UNC's 21-14 victory over Georgia in Athens in 1948 and running back another punt 75 yards for a score in Carolina's 20-14 triumph over William and Mary in 1949. The period of UNC football dating from 1946 to 1949, in which the team appeared in three major bowl games and won two league titles, has been dubbed "The Justice Era."

BLOCKING BACK BILL SUTHERLAND IS one of the few players in the history of Carolina's football program to have his jersey number retired. No UNC player has worn the number 46 since an automobile accident that tragically ended Sutherland's life after his freshman season of 1946. Sutherland was posthumously named cocaptain of the 1947 team.

IN THIS IMAGE, taken moments prior to kickoff of the Carolina–NC State game in Chapel Hill on November 8, 1947, the Tar Heels take the field to the roaring approval of the home fans in Kenan Stadium. UNC made short work of its rival from Raleigh on this particular day, exploding offensively for a 41-6 victory.

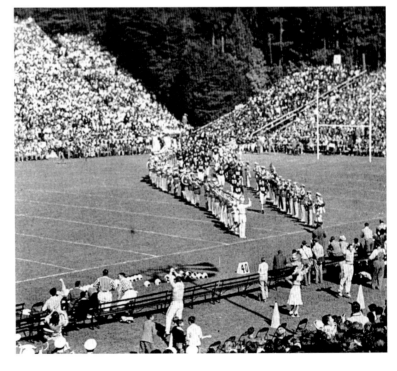

THE JUSTICE ERA

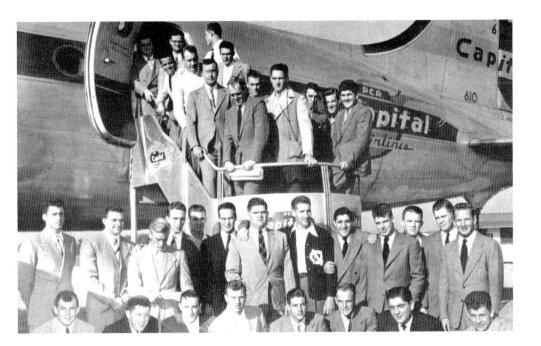

THE STATE OF NORTH CAROLINA IS famous for being "First in Flight," thanks to the exploits of the Wright brothers at Kill Devil Hills in the early 20th century, but it was not until 1947 that the UNC football team flew anywhere for a football game. In this photograph, members of the Tar Heels huddle together for a quick snapshot just prior to flying out to play the Texas Longhorns.

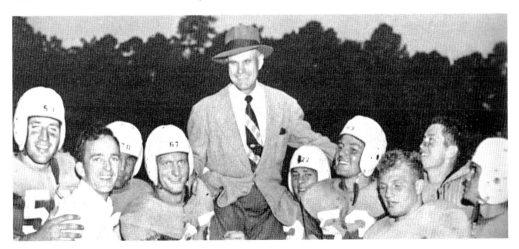

NORTH CAROLINA'S TRIP TO TEXAS in 1947 resulted in a 34-0 defeat, the lone UNC shutout of the Justice era, so it was only fitting that the Tar Heels had revenge on their minds the following year, when the Longhorns came to Chapel Hill. Following Carolina's decisive 34-7 victory, head coach Carl Snavely was hoisted on the shoulders of a couple of his players, while others celebrated nearby.

IN THIS PHOTOGRAPH, TEAMMATES Charlie Justice (left) and Hosea Rodgers seem to have their attention directed elsewhere. A rugged fullback, Rodgers played at UNC before Justice arrived in Chapel Hill, earning All-Southern Conference honors in 1943, but he was also a valuable member of the teams of the Justice era. Rodgers earned four letters at UNC, and in his final game, he scored Carolina's only touchdown in the 1949 Sugar Bowl.

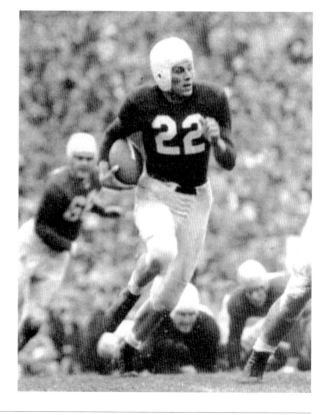

CHOO CHOO JUSTICE WAS MORE than just a football player at the University of North Carolina in the late 1940s. He was a folk hero, a statewide icon whose exploits received national attention. Justice's instincts and breakaway speed were perfectly suited for Carl Snavely's single-wing offense, and Choo Choo ran it to near-perfection.

THE JUSTICE ERA

BILL MACEYKO EARNED THREE LETTERS as a football player at Carolina from 1946 to 1948, playing on the Tar Heel team that won a Southern Conference championship in 1946 and appearing in two Sugar Bowls on January 1, 1947, and January 1, 1949. A talented two-way player who could throw passes on offense and defend in the secondary, Maceyko had one of the greatest single games by a defensive player in school history on November 13, 1948, when he returned two intercepted passes for touchdowns in a 49-20 Carolina victory over Maryland at Washington's Griffith Stadium. The returns, which covered 66 and 59 yards respectively, made Maceyko the first player in school history to bring back two interceptions more than 50 yards for a touchdown in a UNC uniform, a feat that would not be duplicated again for almost 50 years.

LEN SZAFARYN WAS A FINE tackle for Carolina during the Justice era, providing space for Choo Choo and others to work their magic. Behind the blocking of Szafaryn, Justice produced over 2,500 yards of total offense during the 1947 and 1948 seasons, years in which Choo Choo and Len were each named first-team All-Southern Conference. Szafaryn was also named second-team All-American by the Football Writers Association of America in 1948. The Tar Heels were a fast and explosive offensive unit during the Justice era with Szafaryn's help, as the team employed Carl Snavely's single-wing offensive approach. UNC appeared in two Sugar Bowls during Szafaryn's tenure, relying on his athletic blocking to create running room for Carolina's barrage of backs, and Justice in particular. A third-round selection in the 1949 NFL draft, Szafaryn played eight seasons of professional football with the Washington Redskins, Green Bay Packers, and Philadelphia Eagles.

THE JUSTICE ERA

THE 1949 NORTH CAROLINA SQUAD WON the school's last Southern Conference championship. Despite non-conference setbacks to LSU, Tennessee, and Notre Dame, the Tar Heels were one of the most popular teams in the country thanks to the exploits of senior Choo Choo Justice (number 22), the two-time Southern Conference Player of the Year and runner-up for the Heisman Trophy. The team also featured All-Americans Ken Powell (number 53) and Art Weiner (number 50).

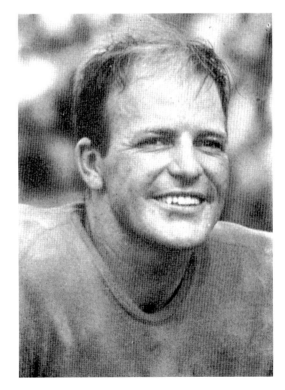

KEN POWELL, SHOWN HERE, WAS AN attractive receiving option for Carolina during the late 1940s while providing an invaluable contribution on defense. An end on both sides of the ball, Powell was named an All-American following the 1949 season for his efforts on defense.

ART WEINER REWROTE CAROLINA'S RECEIVING records during his collegiate career. Weiner led the nation in receptions with 52 in 1949, following up a 1948 season in which he ranked seventh nationally with 31 catches. A three-time selection to the All-Southern Conference team, Weiner's 18 career touchdown receptions established a Carolina school record that would not be broken for nearly 50 years.

IN THIS IMAGE, CHARLIE JUSTICE (RIGHT) POSES with Southern Methodist's Doak Walker (left), who beat him out for the 1949 Heisman Trophy. Justice was named an All-American again in 1949, as North Carolina won the Southern Conference title and met Rice University in the 1950 Cotton Bowl. In his final game as a Tar Heel, Choo Choo struggled to move the football as Carolina was beaten 27-13.

THE JUSTICE ERA

5

THE GREY FOX, KING GEORGE, AND SUNNY JIM

1950–1958

GEORGE SNAVELY COACHED FOOTBALL AT the University of North Carolina for a total of 10 seasons, leading the Tar Heels to a combined record of 59 wins, 35 defeats, and 5 ties. Snavely, a stoic man, was a tireless worker, and according to many of those who knew him well, the only thing Snavely loved comparably to football was vanilla ice cream. Following the 1949 season, Snavely struggled to recruit the same caliber of talent he enjoyed at North Carolina during the Justice era. The advantage of young men returning from the military and attending UNC through the G.I. Bill, which saved the university a lot of money in scholarships, was not really a factor by the early 1950s, and as a result, the talent level on the football team began to sag behind some of Carolina's traditional rivals. After three straight losing seasons from 1950 to 1952, the university elected to replace Snavely with one of his former players, George Barclay.

IRV HOLDASH STARTED THREE SEASONS AS center and linebacker for Carolina from 1948 to 1950, participating on some fine UNC teams. A first-team All-Southern Conference center in 1949, Holdash's blocking that fall paved the way for Choo Choo Justice to break multiple school records and for the Tar Heels to make an appearance in the 1950 Cotton Bowl. Although UNC struggled to a 4-6 overall record during the 1950 season, the year after Justice left Chapel Hill, Holdash was again named first-team All-Southern Conference at center, and he also earned recognition on the Associated Press All-American team. Following a game against Notre Dame on September 30, 1950, Irish quarterback Bobby Williams said that Holdash was the best player he had ever played against. In 1951, Holdash was selected in the seventh round of the NFL draft by the Cleveland Browns.

DICK BUNTING, SEEN HERE throwing a pass, earned three letters at UNC from 1948 to 1950 and served as cocaptain of the 1950 team his senior year. Bunting, like most football players of the era, played both offense and defense, and in 1949, he led the Tar Heels and tied a then-school record with six interceptions.

BUD WALLACE WAS A SOLID punter and defender for Carolina in the early 1950s. Wallace led UNC in punting for three consecutive seasons from 1950 to 1952, and his average of 45.6 yards per punt in 1950 still ranks as the second highest in school history.

BUD CARSON PLAYED AT CAROLINA FROM 1949 to 1951 as a defensive back and return specialist. Carson returned a punt 74 yards for a touchdown in Carolina's 21-0 victory over NC State on September 22, 1951, and led the Tar Heels in punt return yardage during both the 1950 and 1951 seasons. Carson returned to Chapel Hill to coach the junior varsity team in 1957, and later he worked with the Tar Heel defensive backs from 1958 to 1964 under head coaches Jim Tatum and Jim Hickey. After leaving UNC to coach in the professional ranks, Carson developed a relationship with Chuck Noll, who became head coach of the Pittsburgh Steelers in 1969. Carson served as coordinator for the famed "Steel Curtain Defense" of the Steelers from 1972 to 1977, earning two Super Bowl rings and working with some of the greatest players in NFL history.

KEN KELLER EARNED FOUR varsity letters at Carolina in the 1950s and led the Tar Heels in scoring for three straight years from 1953 to 1955. A capable place kicker and kick returner, Keller led the team in total offense in 1953 and 1955, and in 1953, he led the newly formed Atlantic Coast Conference (ACC) in kickoff return average.

WILL FRYE WAS A STANDOUT on George Barclay's Carolina teams of the mid-1950s, which struggled in the years prior to Jim Tatum's return to Chapel Hill. Frye, an end, became the first Tar Heel in history to earn first-team All-ACC honors in two different seasons, which he accomplished in 1954 and 1955. He also led the team in receiving each of those years.

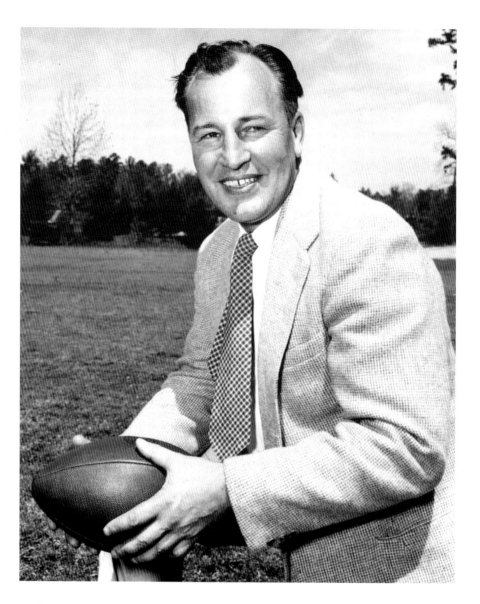

GEORGE BARCLAY, THE FIRST ALL-AMERICAN football player in the history of the Carolina football program, is pictured here during his time as head coach of his beloved alma mater. Barclay had found coaching success elsewhere, leading Washington and Lee to that school's only New Year's Day bowl appearance, the 1951 Gator Bowl against the University of Wyoming, and he become head coach of UNC in 1953, replacing his former coach, Carl Snavely. That season, the first of the new Atlantic Coast Conference, the Tar Heels posted a 4-6 record. Unfortunately Barclay was never able to maximize the full potential of his players at Carolina, as the Tar Heels were a combined 11-18-1 in three seasons until he was replaced following the 1955 season by his former teammate, Jim Tatum. Barclay remained a fixture on the UNC campus in subsequent years, serving as an assistant coach to the varsity and head coach of the freshman team.

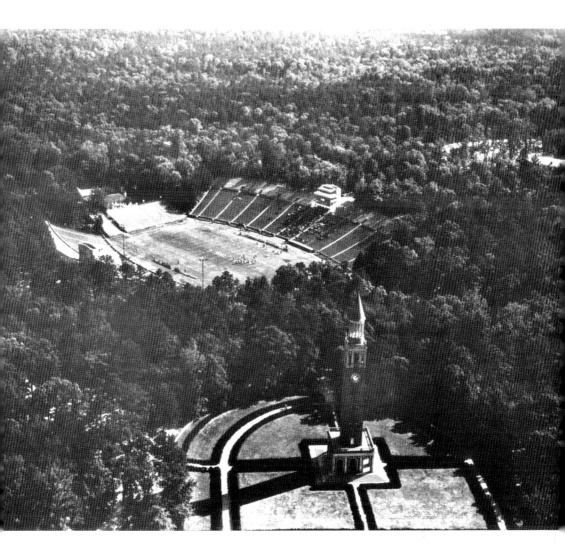

THIS UNIQUE AERIAL IMAGE, TAKEN ABOVE the UNC campus during the spring of 1956, provides an interesting view of Kenan Stadium, the bell tower, and the surrounding area. One can immediately recognize the large abundance of trees that dotted the landscape around the stadium during this era. On this particular day, the Tar Heels were engaged in a spring football practice, and in addition to the players on the field, there are a handful of spectators watching the action in the stands. It was an exciting time in Chapel Hill, as former alumnus Jim Tatum had recently accepted the head coaching position at UNC, giving him a chance to return to the "old rabbit patch," as he liked to call it. Tatum had been a constant winner in recent years at the University of Maryland, and Tar Heel fans were excited to see what "Sunny Jim" had in store for the resurrection of his alma mater's football team.

AFTER STRUGGLING THROUGH A 2-7-1 SEASON in 1956, Jim Tatum's first year back in Chapel Hill as head coach, the Tar Heels enjoyed a resurgence in his second season of 1957, posting a 6-4 record. It was UNC's first winning season on the gridiron since the Justice era. For Tar Heel fans, it provided definitive evidence of Tatum's genius as a football coach.

PHIL BLAZER WAS A STANDOUT for Carolina, earning first-team All-ACC honors as a tackle in 1957 and 1958. A three-time letter winner at Carolina who served as cocaptain of the 1958 team, Blazer was a part of UNC's resurgence in the late 1950s under the confident and steady hand of Jim Tatum.

JIM TATUM, PICTURED HERE PRIOR to the 1957 season, was a larger-than-life figure in college football. A winner everywhere he went, Tatum led Oklahoma to an 8-3 record and victory in the 1946 Gator Bowl before heading to the University of Maryland, where he truly came into his own. The Terrapins posted nine straight winning seasons under Tatum from 1947 to 1955, including an undefeated season in 1951 and ACC titles in 1953 and 1955. Tatum arrived in Chapel Hill with the UNC football program down on its luck, but after a single losing season in 1956, the only one he ever endured as a head coach, "Sunny Jim" guided the Tar Heels to back-to-back winning seasons in 1957 and 1958. Tatum appeared on the verge of putting North Carolina into the nation's football elite when he met a sudden and tragic fate. In July 1959, following a round of golf, Tatum began feeling under the weather, and within hours, he would be dead of what some diagnosed as Rocky Mountain Spotted Fever, a rare illness contracted from ticks.

BUDDY PAYNE WAS A PRODUCTIVE BACK for Carolina during the Tatum years, earning first-team All-ACC honors in 1957, a season in which he also served as the team's cocaptain. Payne tied for the team lead in touchdowns that year and also provided assistance on the defensive side of the ball.

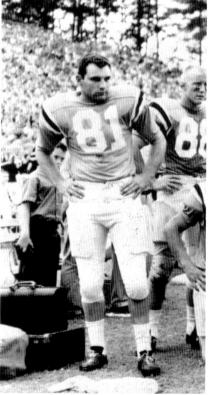

JIM TATUM STOOD BY AL Goldstein following a knee injury that many felt would end his football career. Goldstein repaid Tatum's faith in 1958, when he earned All-American honors as a two-way end. Among Goldstein's more impressive plays that season were a 68-yard touchdown reception and a 46-yard interception return for another score, which helped him earn first-team All-ACC and All-American honors.

THE GREY FOX, KING GEORGE, AND SUNNY JIM

The Jim Hickey Years

1959–1966

Jim Hickey, shown here on the shoulders of some Tar Heel players following Carolina's 41-0 victory over Virginia on November 14, 1959, took over the head coaching job at UNC following the tragic death of Jim Tatum during the summer. Hickey did the best he could to fill Tatum's large shoes under the difficult circumstances, and although the Tar Heels lost their first two games and finished with a 5-5 overall record, the team came together at the end of the year. UNC overwhelmed Virginia and Duke in the last two games of the season, including a 50-0 blowout over the Blue Devils in Durham. Thanks in part to these impressive performances, Hickey remained as head coach of the Tar Heels in 1960 and wound up staying in Chapel Hill as the leader of the UNC football program for the next six years.

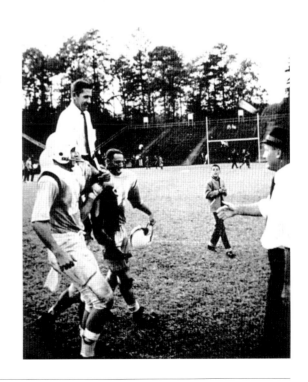

QUARTERBACK JACK CUMMINGS earned three varsity letters at Carolina from 1957 to 1959, and served as cocaptain of the 1959 Tar Heels. Cummings led the team in passing every year from 1957 to 1959, and was named first-team All-ACC in 1958 and second-team All-ACC in 1959.

WADE SMITH WAS A CAPABLE halfback for the Tar Heels in the late 1950s, earning three varsity letters from 1957 to 1959. Smith, a cocaptain in 1959, led UNC in rushing during both the 1958 and 1959 seasons and was named second-team All-ACC both years.

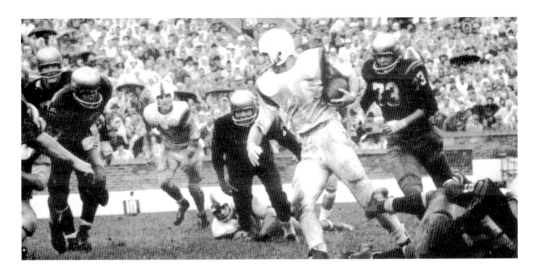

IN THIS IMAGE, TAKEN DURING Carolina's 28-8 defeat against Notre Dame on September 26, 1959, wide receiver Milam Wall (number 40 in white) looks to find additional yardage. Wall was a dependable receiving option for the Tar Heels in the late 1950s and during his senior season of 1960.

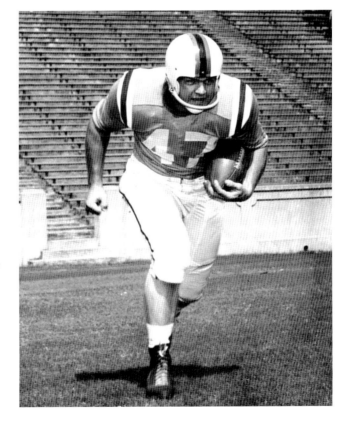

DON KLOCHAK WAS A BRUISING fullback for Carolina in the late 1950s. In his final game as a Tar Heel in 1959, Klochak scored two touchdowns in the memorable 50-0 victory over Duke on Thanksgiving Day in Durham, including a 93-yard kickoff return for a score.

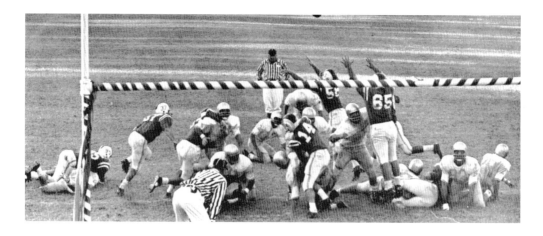

IN THIS IMAGE, PLACE KICKER Bob Elliott has just attempted an extra point to break a 6-6 tie in the fourth quarter of North Carolina's game with Duke on November 19, 1960. The kick sailed through the uprights, giving UNC the critical point that ultimately led to a 7-6 upset victory over the ACC champion and Top 10 Blue Devils, who were on their way to the 1961 Cotton Bowl.

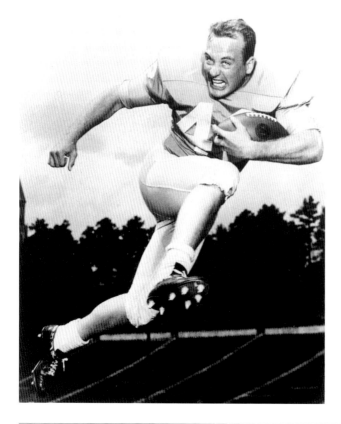

BOB ELLIOT PLAYED FULLBACK at Carolina in the early 1960s, earning second-team All-ACC honors in 1960 and first-team All-ACC honors in 1961. A cocaptain in 1961, Elliott was also useful as a place kicker in these years, making multiple important conversions for the Tar Heels.

THE JIM HICKEY YEARS

QUARTERBACK RAY FARRIS WAS among the heroes of Carolina's 7-6 upset of sixth-ranked Duke in 1960, tallying 148 yards of offense and scoring the game's only touchdown in the fourth quarter. In 1961, Farris led the Tar Heels to a dramatic 22-21 victory over Tennessee, throwing a 23-yard touchdown pass and adding a two-point conversion in the final seconds.

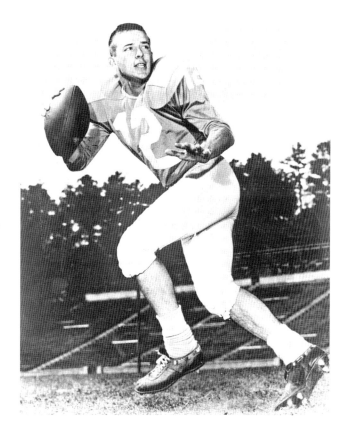

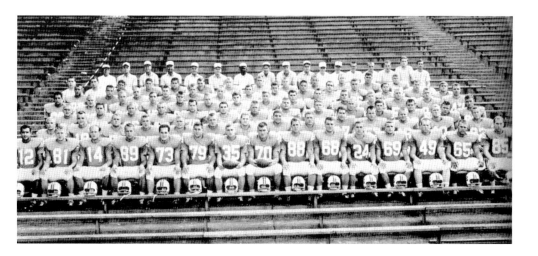

THE 1963 TAR HEELS WERE the crowning jewel of the Jim Hickey era, posting a 9-2 record and claiming a share of the ACC regular-season title to receive an invitation to the Gator Bowl. Behind nearly 400 yards of offense and a strong defensive effort, the Tar Heels shut out Air Force 35-0 to give the program its first victory in a postseason football game.

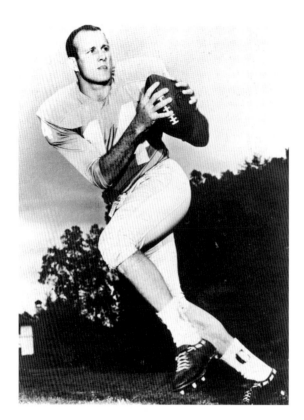

QUARTERBACK JUNIOR EDGE, SHOWN here, was a first-team All-ACC selection in 1963, when he served as one of the catalysts of Carolina's march to the Gator Bowl and a share of the school's first ACC title. Edge led the Tar Heels in passing during both the 1962 and 1963 seasons, combining for just under 2,400 passing yards over those years.

EDDIE KESLER PROVIDED SUPERIOR lead blocking for Carolina in the Hickey years, while taking plenty of carries of his own. Kesler helped lead UNC to a 9-2 record and victory in the 1963 Gator Bowl, and on November 21, 1964, Kesler dazzled the crowd in Kenan Stadium by rushing for a then-school record 172 yards, leading the Tar Heels to a 21-15 victory over Duke.

THE JIM HICKEY YEARS

RONNIE JACKSON EARNED THREE varsity letters at Carolina in the mid-1960s, providing assistance as a receiver and specialist. Jackson led UNC, and the rest of the ACC, in receiving in 1964, catching 34 passes for 512 yards and 5 touchdowns. He also led Carolina in kickoff return yardage that season, as he averaged 25.8 yards per return.

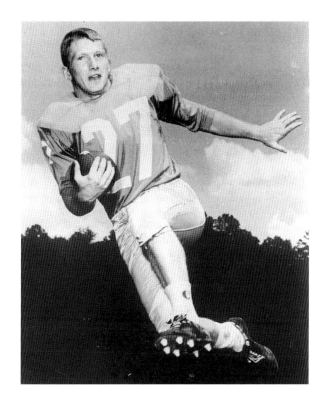

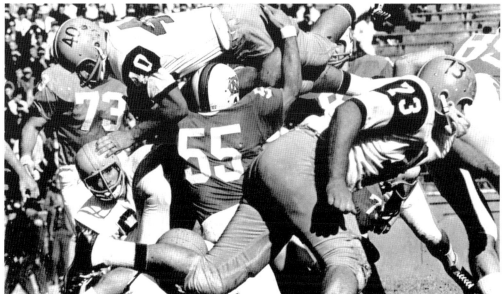

IN THIS PHOTOGRAPH, TAKEN DURING Carolina's game against Miami in Kenan Stadium on November 16, 1963, linebacker Chris Hanburger (number 55) stops the forward pursuit of running back Pete Banaszak. Hanburger was named first-team All-ACC as a center following both the 1963 and 1964 seasons and also played well at linebacker.

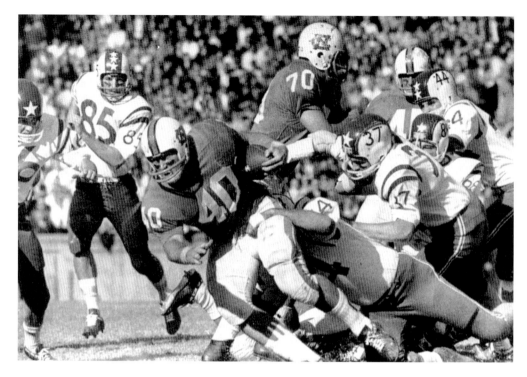

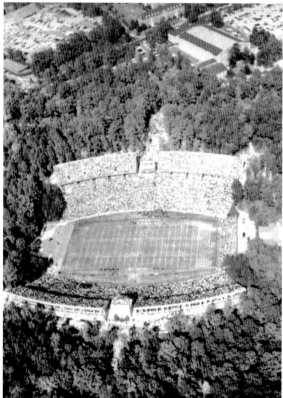

KEN WILLARD (NUMBER 40), LED UNC in rushing every season from 1962 to 1964. Willard led the ACC in rushing in 1963 and followed up the regular season with a 94-yard performance in UNC's Gator Bowl triumph over Air Force. The following year, Willard became the first player in Carolina history to be taken in the first round of an NFL draft.

WHILE THE TAR HEELS WERE NOT AT the top of the ACC standings during the mid-1960s, it did not deter fans and students from crowding into Kenan Stadium on fall Saturdays, as seen in this aerial shot taken from a game in 1965. Kenan had yet to undergo extensive renovations in both the east and west end zones when this particular photograph was taken.

THE JIM HICKEY YEARS

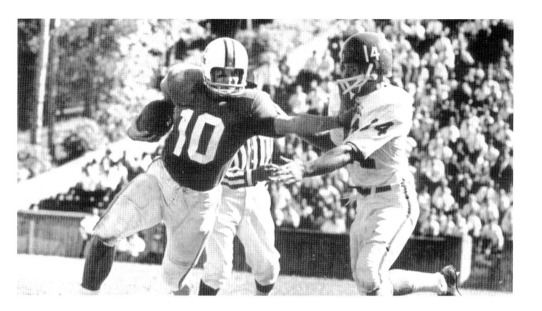

In this image, quarterback Danny Talbott (number 10) stiff-arms a Michigan State defender during Carolina's 21-15 victory over the Spartans in 1964. Talbott led the Tar Heels in passing in 1965 and 1966, years in which he helped Carolina pull off upsets against Ohio State and Michigan. Following the 1965 season, in which he threw for 1,080 yards and only three interceptions, Talbott was named the ACC's Player of the Year.

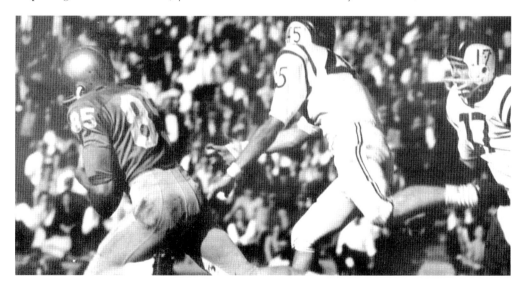

Bob Lacey (number 85) was one of the top wide receivers in the ACC in the 1960s, earning All-American honors from the Associated Press following UNC's impressive 1963 season. Lacey led the Tar Heels in receiving in 1962 and 1963 and, along the way, became the first UNC receiver to post 40 or more receptions in consecutive seasons. He was also a two-time All-ACC selection.

IN THIS IMAGE, WIDE RECEIVER CHARLIE Carr (number 80) hauls in a catch during Carolina's 20-14 defeat to Air Force on November 12, 1966. The 16 receptions by Carr established a single-game school record that still stands to the present day. Carr led the ACC with 52 receptions in 1966.

DAVID RIGGS WAS A DANGEROUS return man for UNC in the 1960s, leading the team in punt returns in 1965 and 1966 and kick returns in 1966 and 1967. Among his best returns were a 67-yarder for a touchdown in Carolina's 17-13 victory over Clemson in 1965 and a 73-yarder at Michigan in 1966. Riggs's 715 return yards that autumn established a school record that stood for a quarter-century.

THE JIM HICKEY YEARS

THE OLD TRENCH FIGHTER

1967–1977

GAYLE BOMAR, SEEN HERE SCRAMBLING for yardage, became Bill Dooley's first quarterback project at Carolina, moving over from safety during Dooley's initial spring as head coach of the UNC football program in 1967. Dooley brought a fresh approach to Chapel Hill, one that was wrought in the pursuit of mental toughness and relentless precision on the football field. Effective as both a runner and a passer, Bomar led the Tar Heels in total offense during both the 1967 and 1968 seasons, combining for more than 3,100 yards and 19 touchdowns over those years. Although the Tar Heels struggled during Bomar's two seasons as starting quarterback, posting a combined record of just 5 wins and 15 losses, he did enjoy some fine individual performances. On October 26, 1968, Bomar accumulated 326 yards of total offense in the second half of a game against Wake Forest, establishing a school record that hasn't been broken in the years since.

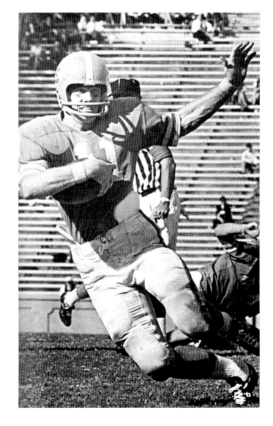

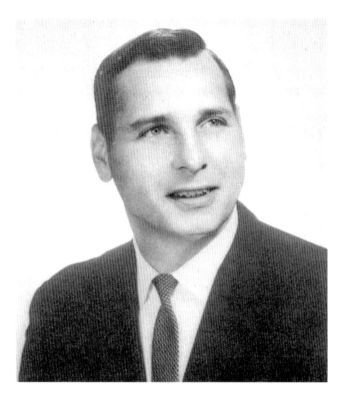

BILL DOOLEY TOOK THE HEAD coaching job at Carolina during a rough period in the school's gridiron history. The Tar Heels were coming off a 2-8 season in 1966 and owned just 3 winning seasons over 17 years when Dooley chose UNC over two other jobs he had been offered. Dooley gradually turned around Carolina's football fortunes, posting a .500 record by his third season of 1969.

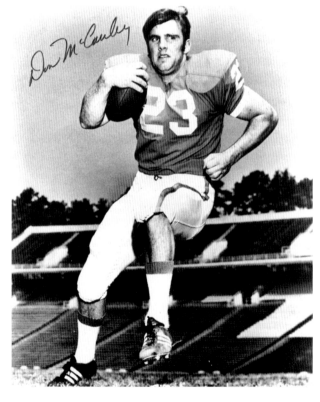

DON MCCAULEY WAS AMONG THE first batch of high-school recruits Bill Dooley successfully recruited to Chapel Hill when he arrived at North Carolina following the 1966 season. A hard-charging, workhorse running back, McCauley carried the brunt of the offensive load for UNC during the 1969 and 1970 seasons and was a major reason why the Tar Heels started rising in the ACC standings.

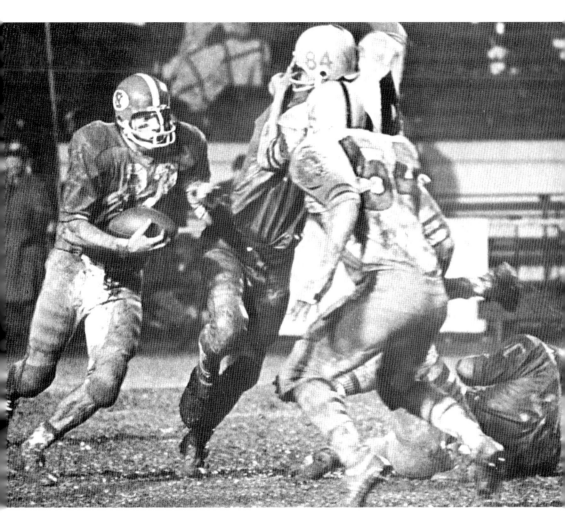

IN THIS PHOTOGRAPH, TAKEN DURING NORTH Carolina's 1970 Peach Bowl encounter with Arizona State University (ASU), Don McCauley searches for some running room. On this night, McCauley established UNC postseason records with 36 rushing attempts and three rushing touchdowns, although the Tar Heels were ultimately beaten by ASU 48-26. McCauley was named the ACC's Player of the Year as a junior in 1969, a season in which he led the league with 1,092 yards and helped the Tar Heels reach the .500 mark for the first time since 1964. Taking advantage of Bill Dooley's run-heavy offensive approach as a senior in 1970, McCauley etched his name in the annals of college football's history books when he rushed for a then-NCAA record 1,720 yards. McCauley established the impressive mark during his final game in Kenan Stadium, when he rushed for 279 yards, which stood as the ACC single-game record for seven years, in a 59-34 victory over archrival Duke. A first-round selection of the Baltimore Colts in the 1971 NFL draft, McCauley played 11 seasons of professional football.

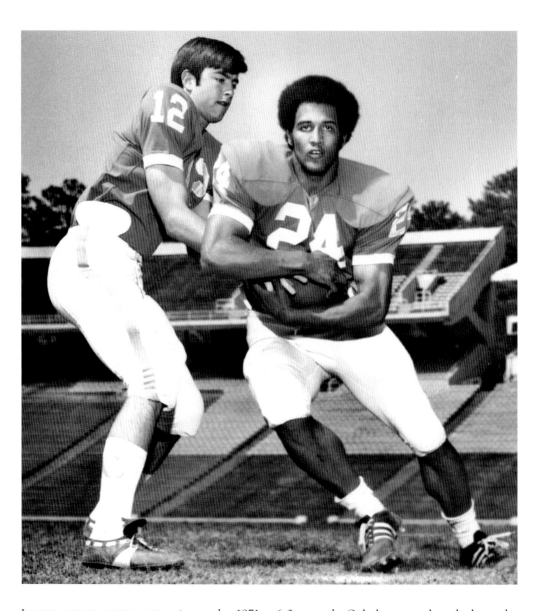

IN THIS IMAGE, TAKEN JUST prior to the 1971 football season, quarterback Paul Miller (number 12) hands off to running back Ike Oglesby (number 24). Miller led the Tar Heels in passing in 1970 and 1971, and his 1,041 yards in 1971 led the entire ACC, helping him earn first-team All-Conference honors at quarterback. Thanks to Miller's contributions, Carolina led the league in total offense that season, with an average of 365 yards per game, as they won the conference title with a perfect 6-0 record. Oglesby was slowed down by injuries during his UNC career, but there were glimpses of brilliance, such as the 167 yards he accumulated on 39 carries against Illinois on September 18, 1971, and the 99 yards he piled up during the first half of a 31-20 victory over Kentucky in Kenan Stadium on October 14, 1972. Oglesby's rushing helped the Tar Heels claim back-to-back league titles in 1971 and 1972, going a perfect 12-0 in ACC play over that period.

THE OLD TRENCH FIGHTER

BILL ARNOLD MET A TRAGIC fate on the
UNC practice field in 1971. During a
scorching preseason practice session,
Arnold became overheated and collapsed.
After an extended period in the hospital,
Arnold died from complications created
by the onset of heat exhaustion. Arnold's
death was an eye-opener to the university,
and it resulted in the advent of a sports
medicine curriculum at UNC–Chapel Hill.

LEWIS JOLLEY, SEEN HERE DURING a 1971
game, took over as the starting running
back at UNC following the graduation of
Don McCauley. Jolley made the most of
his opportunity, leading the team with 707
rushing yards in 1971. He caught fire at
the end of the regular season, with a 171-
yard rushing effort against Virginia and a
159-yard outing against Duke in Carolina's
final two regular-season games.

JOHN BUNTING WAS A BIG REASON for the improvement of the Carolina defense under Bill Dooley in the early 1970s. A rugged, hard-nosed defender, Bunting was named first-team All-ACC in 1971, a year in which the Tar Heels rose to the top of the ACC. The Tar Heels ranked first in the ACC in total defense during both the 1970 and 1971 seasons and also ranked first in rushing defense both years. With Bunting patrolling the middle during his junior year, the Tar Heels were particularly stingy in 1970, giving up just 95.3 rushing yards a game. Bunting had a pair of interceptions in Carolina's 35-14 victory over Maryland in 1971, including one in which he returned 32 yards for a touchdown. Drafted by Philadelphia in the 10th round of the 1972 NFL draft, Bunting spent 11 years with the Eagles and started in Super Bowl XV in January 1981.

THE OLD TRENCH FIGHTER

LOU ANGELO STARTED ON UNC teams that won 28 games from 1970 to 1972, earned two ACC titles, and participated in three bowls. Angelo established school records for career interceptions (16) and single-season interceptions (8), each of which stood for two decades.

NICK VIDNOVIC WAS THE STARTING quarterback during Carolina's magical fall of 1972. Although he was knocked out of the Wake Forest game after a collision, Vidnovic returned the following game to help Carolina produce 496 yards against Clemson. In the Sun Bowl against Texas Tech, Vidnovic led UNC to a come-from-behind victory, throwing two touchdown passes and adding a two-point conversion in the second half.

RON RUSNAK WAS ONE OF THE PREMIERE interior linemen in the ACC in the early 1970s, claiming the Jacobs Blocking Trophy as the league's top blocker in 1972. He was also named first-team All-ACC and first-team All-American that year, helping the Tar Heels lead the league in rushing yardage with an average of 244 yards per game.

SAMMY JOHNSON (NUMBER 48) was recruited to Carolina to play quarterback, but he eventually found his niche as a running back, where he ran for 1,006 yards in 1973. The total, which earned Johnson recognition on the All-ACC first team, ranked second in the league that fall. A fourth-round selection of the San Francisco 49ers in the 1974 NFL draft, Johnson played professionally for six seasons.

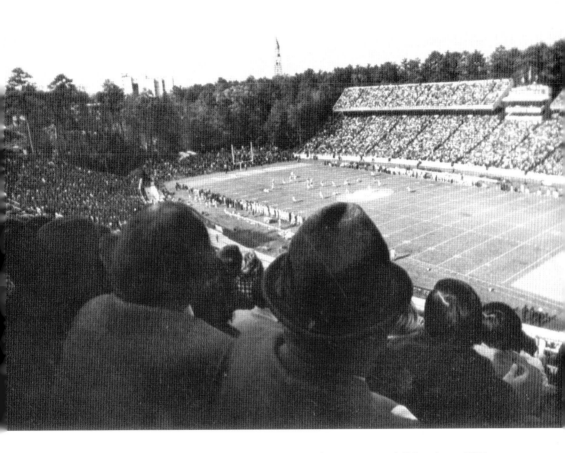

Kenan Stadium has always been an entertaining place to spend a Saturday afternoon in the fall months, but that was particularly the case in the autumn of 1972, the year this photograph was taken. Fans that attended games in Kenan that fall were treated to a heart-stopping, frantic style of football, played by a group of young men who would become known as the "Cardiac Kids" by their head coach, Bill Dooley. The Tar Heels, on their way to a school-record 11 victories and a second consecutive ACC title in 1972, were a perfect 6-0 in Kenan Stadium during the regular season, which included a classic victory over North Carolina State that determined the ACC championship. Billy Hite scored the game-winning touchdown with less than a minute to play, and the Tar Heel defenders withstood a last-second Wolfpack score and subsequent two-point conversion attempt for a dramatic 34-33 victory.

CHRIS KUPEC (NUMBER 12) WAS THE starting quarterback of the 1974 UNC team that finished 7-5 and played in the Sun Bowl. Kupec led Carolina with 1,474 passing yards, which established a new school record, and his 12 passing touchdowns tied a record previously set by Choo Choo Justice. In addition, Kupec led the nation in completion percentage, connecting on 69.3 percent of his passes, to earn first-team All-ACC honors.

CHARLES WADDELL WAS ONE OF the top tight ends in the ACC in the 1970s, earning first-team All-Conference honors in 1973. Waddell had a tremendous game against Clemson in 1974, catching three touchdown passes in Carolina's 54-32 loss to the Tigers. He was also an aggressive blocker who provided running room for multiple 1,000-yard backs. Following the 1974 season, Waddell was named an All-American by *The Sporting News*.

THE OLD TRENCH FIGHTER

ELLIS ALEXANDER EARNED THREE letters as a kicker at Carolina from 1972 to 1974, playing on Tar Heel teams that won an ACC title in 1972 and appeared in two bowls. Alexander established a school record with 35 extra point conversions in 1972, and in 1973, he made a 53-yard field goal against NC State, which also established a new school record. Both have since been broken.

JIMMY JEROME (NUMBER 40) LED NORTH Carolina in receiving for three straight seasons from 1972 to 1974. In 1974, Jerome earned All-ACC honors with 837 receiving yards, which set a single-season school record that lasted for nearly two decades. In October 1975, Jerome was tragically killed in a car accident in California. Today the player's lounge in the Football Center at Kenan Stadium is named in Jerome's memory.

KEN HUFF WAS A FEARSOME blocker at Carolina from 1972 to 1974, providing holes for some of the better running backs in school history, including 1,000-yard rushers Sammy Johnson, James "Boom Boom" Betterson, and Mike Voight. A three-year letter winner, Huff was one of the best offensive linemen in the country during the 1974 season, earning first-team All-American honors from media organizations including the Associated Press, *The Sporting News*, and *Time* magazine. In helping the Tar Heels set a then-school record with 4,691 yards of total offense in 1974, which ranked fifth nationally, Huff was awarded the Jacobs Blocking Trophy as the top offensive lineman in the ACC. He was also a cocaptain of the Tar Heels that fall. The third overall selection in the 1975 NFL draft by the Baltimore Colts, Huff enjoyed a professional career that lasted a decade.

THE OLD TRENCH FIGHTER

JAMES BETTERSON, SEEN RUNNING
the ball during a game at Clemson,
was half of a historic rushing tandem
for Carolina during the fall of 1974.
Betterson, more affectionately known as
"Boom Boom," rushed for 1,082 yards to
lead the Tar Heels while joining Mike
Voight as the first pair of teammate
running backs in NCAA history to
rush for 1,000 yards in the same season.

ROD BROADWAY STARTED THREE
seasons at defensive tackle for
Carolina, making his first splash as a
sophomore in 1974 with a tremendous
performance in UNC's 33-14 victory
over NC State. Despite struggling
through injuries, including a severe
knee injury that kept him out for the
entire 1976 season, Rod bounced back
with a vengeance in 1977 to help
form one of the best defensive lines in
America that fall.

UNIVERSITY OF NORTH CAROLINA FOOTBALL

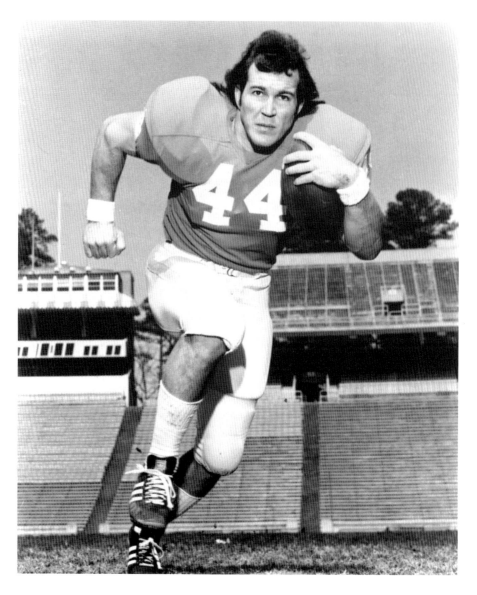

MIKE VOIGHT WAS ONE OF the top running backs in the ACC in the mid-1970s, earning the league's Player of the Year Award following both the 1975 and 1976 seasons. Voight rushed for more than 1,000 yards for three consecutive years from 1974 to 1976, and as a senior, he ran for 1,407 yards, which was, at the time, the second highest single-season rushing total in ACC history. Voight saved his best performance for the last game of his senior year in the annual battle with Duke. Voight ran 41 times for a career-best 261 yards and added a two-point conversion in the final minute in Carolina's 39-38 victory. Disappointingly Voight injured his ankle in the days leading up to the 1976 Peach Bowl, and the Tar Heels were subsequently shut out by Kentucky, 21-0. Nonetheless, Voight was named second-team All-American after the season by both the Associated Press and the United Press International.

THE OLD TRENCH FIGHTER

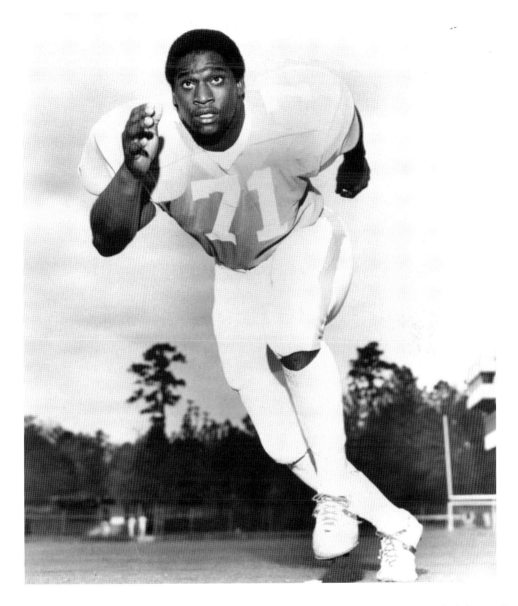

DEE HARDISON WAS A DOMINATING DEFENSIVE tackle for Carolina in Bill Dooley's last two seasons in Chapel Hill, earning first-team All-ACC honors in 1976 and 1977. In his junior season of 1976, Hardison headlined a defense that helped UNC go 4-1 in conference play and finish with an overall record of 9-3. The following year, Hardison was a first-team All-American and the premiere player on a defense that allowed only 7.4 points a game during the regular season, and he led the ACC in rushing defense, passing defense, and total defense. The Tar Heels held six opponents to a touchdown or less in 1977 in winning Dooley's third and final ACC championship. A second-round selection in the 1978 NFL draft, Hardison played 11 seasons with teams including the Buffalo Bills, New York Giants, and San Diego Chargers.

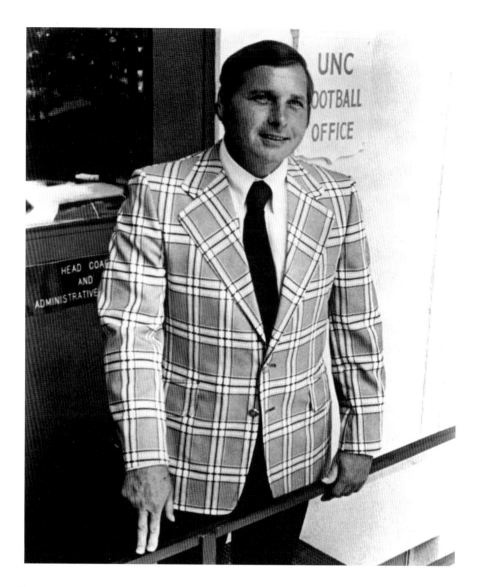

BILL DOOLEY, PICTURED HERE IN front of the UNC football offices, was the head coach at Carolina for 11 years from 1967 to 1977, winning 69 games, losing 53, and tying twice. A talented offensive coaching mind groomed under the likes of Darrell Royal of Texas and his brother Vince, the longtime head coach at Georgia, Bill gradually turned around North Carolina's football fortunes, posting a .500 record by his third season of 1969 and winning back-to-back ACC titles in 1971 and 1972, along with a third league title in 1977.

Nicknamed the "Old Trench Fighter," Dooley is remembered for his efficient, grueling practices and offensive units that produced highly effective running games at UNC. Dooley chose to become the head football coach and athletic director at Virginia Tech following the 1977 season, but he left behind some talented players for the next coaching staff to work with, which helped the Tar Heels stay competitive in the Atlantic Coast Conference standings after his departure.

THE OLD TRENCH FIGHTER

THE DICK CRUM YEARS

1978–1987

DICK CRUM REPLACED BILL DOOLEY as head coach at Carolina following the 1977 season and wound up leading the Tar Heels for a decade. Carolina went 5-6 in Crum's first season of 1978, but from 1979 to 1983, Crum guided UNC to five consecutive winning seasons, an ACC title in 1980, and victories in four straight bowl games. Along the way, Crum won 72 football games, more than any other head coach in school history. Carolina continued to churn out 1,000-yard running backs during the Crum years, as standouts including Amos Lawrence, Kelvin Bryant, Ethan Horton, and Tyrone Anthony provided fans numerous thrills. The Tar Heels spent quite a bit of time in the national rankings early in Crum's tenure, but the Tar Heels struggled with mediocrity in the mid-1980s, posting a 22-21-2 record from 1984 to 1987. Following the 1987 season, the university bought Crum out of his contract.

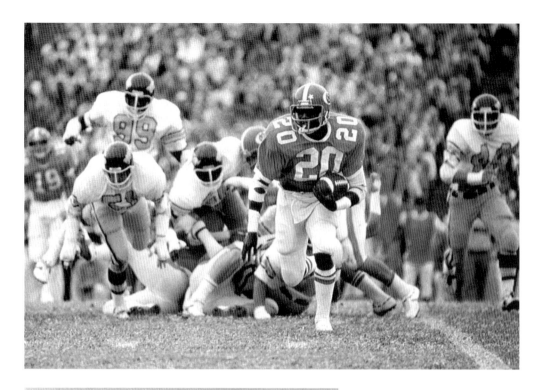

Amos Lawrence (number 20) took the ACC by storm during his freshman season in 1977, leading the league with 1,211 rushing yards to win Rookie of the Year honors. Lawrence ended his college career in 1980 as the only player in ACC history to rush for 1,000 yards in four consecutive seasons.

Guard Mike Salzano provided outstanding blocking for tailbacks Mike Voight and Amos Lawrence during his career, which spanned from 1975 to 1978. Salzano matured into a superb run blocker during his time in Chapel Hill and was named first-team All-ACC following both the 1977 and 1978 seasons.

THE DICK CRUM YEARS

Buddy Curry was a dominant linebacker for the Tar Heels in the late 1970s, earning first-team All-ACC honors in 1977 and 1979. An intelligent player with a knack for getting to the ball, Curry broke the school's single-season record for tackles in his junior and senior seasons, with 155 in 1978 and 171 in 1979. The mark Curry established in 1979 remains first in the school rankings.

Ricky Barden was one of the top defensive backs in the ACC in the late 1970s, earning first-team All-Conference honors in 1978 and 1979. Barden led Carolina with four interceptions in 1978 and finished his career with nine pickoffs. A four-year letter winner, Barden helped the Tar Heels reach the Gator Bowl his senior year and finish with an overall record of 8-3-1.

UNIVERSITY OF NORTH CAROLINA FOOTBALL

MATT KUPEC WON 24 GAMES AS starting quarterback at Carolina and participated in three bowls from 1976 to 1979. Kupec led the ACC in passing in 1979, throwing for 1,587 yards and 18 touchdowns. Kupec threw three touchdowns in his two postseason appearances and was named MVP of the 1977 Liberty Bowl, although the Tar Heels lost to Nebraska.

TIGHT END MIKE CHATHAM WAS a primary receiving option during his playing days at Carolina, leading the team in receptions in 1979 and 1980. Chatham was particularly effective during his junior season of 1979, earning first-team All-ACC honors after making 29 catches for 448 yards, an average of 15.4 yards per reception, to go along with eight touchdown grabs.

THE DICK CRUM YEARS

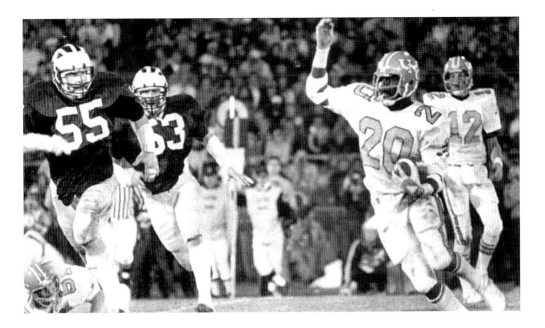

IN THIS IMAGE, TAKEN DURING the 1979 Gator Bowl between UNC and Michigan, Amos Lawrence seeks a running lane. Lawrence ran 23 times for a game-high 118 yards, earning co-Player of the Game honors in leading the Tar Heels to a 17-15 victory. Lawrence ran for 100 or more yards on 25 different occasions at Carolina, including a 286-yard effort against Virginia in 1977 that set a then-NCAA freshman record.

RUNNING BACK DOUG PASCHAL IS one of the more underrated players in Carolina's football history. Playing behind Mike Voight and Amos Lawrence limited Paschal's opportunities at UNC, but that didn't stop him from making his own mark. Paschal was Carolina's second leading rusher during both the 1978 and 1979 seasons, and in 1979, he stepped in and started four games for an injured Lawrence, contributing 835 yards.

LAWRENCE TAYLOR MADE HIS FIRST run at football immortality at the University of North Carolina in the late 1970s. Recruited originally as a defensive lineman, Taylor was converted to an outside linebacker in 1979, where he became a legend. Capable of taking over games with his combination of speed and instinct, Taylor often made plays from the other side of the field, as teams would run away from him as much as possible. With a pass rush that was far ahead of its time, Taylor went on to set a UNC single-season record in 1980 with 16 sacks. A first-round selection of the New York Giants in the 1981 NFL draft, Taylor revolutionized his position in the professional game, becoming one of the greatest defensive players in football history. The 1986 NFL Most Valuable Player, Taylor is a member of the NFL's 75th Anniversary Team, and in 1999, he was inducted into the Pro Football Hall of Fame.

THE DICK CRUM YEARS

STEVE STREATER EARNED FOUR LETTERS AT North Carolina from 1977 to 1980 and served as cocaptain of the Tar Heels during one of the best seasons in school history. Streater was named first-team All-ACC as both a defensive back and a punter in 1980, serving as a key player on a Carolina team that won the ACC title and finished with an 11-1 record. In UNC's Bluebonnet Bowl victory over Texas that year, Streater was named Defensive Most Valuable Player after recording an interception and a fumble recovery and booming a 66-yard punt.

Steve signed a contract with the Washington Redskins and was preparing to begin a career in the NFL when tragedy struck. In April 1981, Streater was involved in an automobile accident that left him paralyzed from the waist down. In a moving scene the following fall in UNC's season opener, a 56-0 victory over East Carolina, Kelvin Bryant handed the ball with which he scored his sixth touchdown to Streater, who was sitting in the end zone watching the game.

DEFENSIVE TACKLE DONNELL Thompson was a three-year starter at UNC from 1978 to 1980. Following the 1980 season, in which Carolina held eight of its opponents to 10 points or fewer and finished with an 11-1 overall record, Thompson was named first-team All-ACC and third-team All-American by *The Football News*. Thompson was selected in the first round of the 1981 NFL draft by the Baltimore Colts.

GUARD RON WOOTEN WAS A FOUR-year letter winner at Carolina and served as cocaptain of the 1980 team, which won the school's last ACC championship in football. A second-team All-American selection by *The Football News* in 1979, Wooten was awarded the Jacobs Blocking Trophy in 1980 as the ACC's best blocker. He was also named first-team All-American.

THE DICK CRUM YEARS

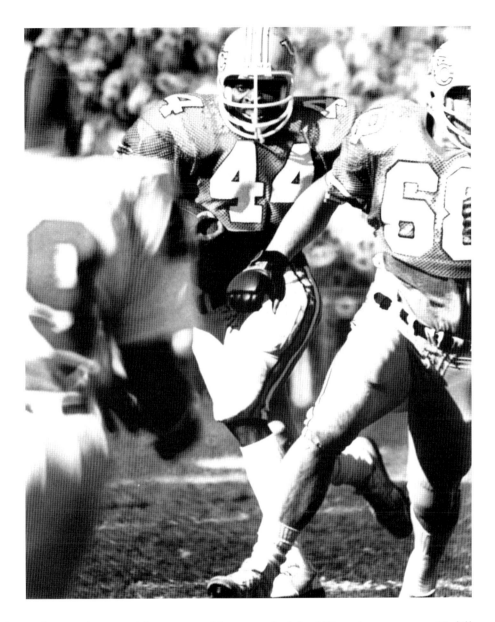

KELVIN BRYANT (NUMBER 44) WAS named first-team All-ACC for three consecutive seasons from 1980 to 1982, all years in which he ran for 1,000 yards in the UNC backfield. Bryant teamed with Amos Lawrence to create a highly productive running game for the Tar Heels in 1980, and the following year, despite playing in only seven games, Bryant returned to post 1,015 yards. In three seasons as one of the featured backs at Carolina, Bryant rushed for 100 yards or more on 19 different occasions, including a 247-yard outing against Duke in 1981 and a 211-yard game against East Carolina in the season opener that same year. Also in the East Carolina game, Bryant rushed for an amazing six touchdowns. Bryant currently holds an NCAA record for most touchdowns scored in a period of two games (11) and three games (15), respectively.

DARRELL NICHOLSON WAS NAMED the ACC's Rookie of the Year in 1978, a season in which he made a major impact on the Carolina defense. The following season, Nicholson posted 147 tackles, and he followed it up his senior year by being named first-team All-ACC in 1980, teaming with Lawrence Taylor to create a fearsome defensive unit.

DAVID DRECHSLER WAS ONE OF the top offensive linemen in the ACC in the early 1980s, earning first-team All-American honors in 1981 and 1982. He played every position along the offensive line during his career but found a home at guard, where he started his junior and senior years after recovering from two knee operations.

THE DICK CRUM YEARS

ROD ELKINS WAS A PRODUCTIVE quarterback at Carolina in the early 1980s, tying for the ACC lead in passing with 1,002 yards in 1980. Elkins was having a fine season in 1981 until suffering an ankle injury, which limited him for five games. In the third game in 1982, Elkins tore cartilage and ligaments in his knee, and he would make only two more appearances in a Tar Heel uniform.

BRIAN BLADOS WAS ONE OF the best college offensive tackles of his time, earning first-team All-American honors in 1983. During Blados's three years as a starter, Carolina's running backs amassed 7,074 rushing yards and 68 touchdowns. In Blados's final two seasons in 1982 and 1983, the Tar Heels established new school total offense records, finishing sixth and seventh in the country in total offense those years.

A FAST AND AGGRESSIVE DEFENSIVE TACKLE, William Fuller anchored the Carolina defensive line in the early 1980s. A three-year starter, Fuller burst onto the scene as a sophomore in 1981, contributing 22 tackles for loss and 9 sacks in helping the Tar Heels produce a 10-2 overall record. In 1982, Fuller added 13 tackles for loss and 6 sacks, earning All-American honors as Carolina finished 8-4 and defeated Texas 26-10 in the Sun Bowl. In 1983, Fuller earned first-team All-American recognition after posting 22 tackles for loss and 5 sacks. Opposing offensive lines found it extremely difficult to contain Fuller, a big and athletic young man with tremendous desire and technique. A four-time Pro Bowler in the National Football League with the Houston Oilers and Philadelphia Eagles, Fuller ranks first in UNC school history with 57 career tackles for loss.

SCOTT STANKAVAGE WAS THRUST INTO THE limelight in 1981 following an injury to prior starting quarterback Rod Elkins. Stankavage led Carolina in passing during the 1982 and 1983 seasons, combining for more than 2,800 passing yards over those two years.

TYRONE ANTHONY (NUMBER 8) celebrates Carolina's 34-27 victory over Duke on November 19, 1983, in the first night game in the history of Kenan Stadium. Anthony, who rushed for a career-high 232 yards in the victory, joined the ever-growing list of Tar Heel running backs to eclipse the 1,000-yard plateau in 1983, as he rushed 184 times for 1,063 yards.

ETHAN HORTON (TOP), SEEN HERE LEAPING over the pile to score a touchdown, continued Carolina's tradition of 1,000-yard running backs in the 1980s, turning the trick during the 1983 and 1984 seasons. After gaining 1,107 yards during the 1983 season, Horton followed it up with a 1,247-yard performance in 1984, which earned him ACC Player of the Year honors. It was the 12th consecutive season in which at least one running back from North Carolina gained 1,000 or more yards. Horton saved some of his best performances as a Tar Heel for the biggest games, earning co-MVP honors after scoring two touchdowns and rushing for 148 yards in UNC's victory over Arkansas in the 1981 Gator Bowl and earning MVP honors with 119 rushing yards and a touchdown in Carolina's victory over Texas in the 1982 Sun Bowl. He was a selection of the Kansas City Chiefs in the 1985 NFL draft.

THE DICK CRUM YEARS

Troy Simmons (number 41) earned three letters at Carolina from 1983 to 1985. A linebacker, Simmons enjoyed one of the finest seasons by a defensive player in school history in 1984, posting 162 tackles. The total, which ranked second in school history at the time, still ranks third in all-time single-season tackles at Carolina.

Linebacker Carl Carr tied for Carolina's team lead in 1985 with 162 tackles, along with teammate Brett Rudolph. The number ranks as the third highest single-season total in school history. On November 24, 1984, Carr came up with one of the finest efforts ever made by a UNC defender on a single play, returning a fumble 96 yards for a touchdown in Carolina's 17-15 victory over Duke.

QUARTERBACK KEVIN ANTHONY got plenty of chances to throw the football during his career at Carolina. In 1984, Anthony set then-school records for passing attempts (265) and passing yards (1,786) in a season. The following year, Anthony set more school records when he attempted 53 passes, completing 31, in a 23-13 loss to LSU.

EARL WINFIELD, A FOUR-LETTER LETTERMAN at Carolina, was the primary beneficiary of Kevin Anthony's passing in 1984 and 1985. Winfield led the Tar Heels in receiving both years, and his 696 receiving yards and eight touchdowns in 1985 helped him earn first-team All-ACC honors that season.

THE DICK CRUM YEARS

DERRICK FENNER (NUMBER 12) WAS the last 1,000-yard running back to play for the Tar Heels under Dick Crum. Fenner gained 1,250 yards during the 1986 season, which led the ACC and earned him first-team All-Conference honors. On November 15, 1986, Fenner had perhaps the finest game ever enjoyed by a Tar Heel offensive player, rushing for a school-record 328 yards in a 27-7 victory over Virginia in Kenan Stadium.

HARRIS BARTON, A FOUR-YEAR STARTER at center and offensive tackle for North Carolina, blocked for 1,000-yard backs including Ethan Horton, Kevin Anthony, and Derrick Fenner. During his senior year of 1986, Barton helped UNC rank first in the ACC, and sixth nationally, in total offense. A first-team All-American that year, Barton went on to win three Super Bowl rings with the San Francisco 49ers.

BRETT RUDOLPH PLAYED AT North Carolina from 1984 to 1987. A linebacker, Rudolph made perhaps his biggest mark as a sophomore in 1985, when he tied with Carl Carr for the team lead with 162 tackles. It was, at the time, the second highest single-season total in school history.

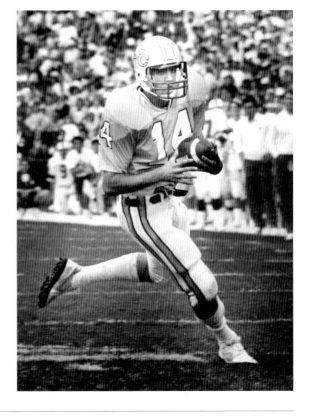

MARK MAYE LED THE ACC in passing in 1986 with 1,401 yards and 10 touchdowns. That year, Maye gained 193 yards of offense in the fourth quarter alone against NC State, although the Tar Heels lost the game 35-34. Maye also has the distinction of throwing the longest touchdown pass in school history, a 93-yard strike to Randy Marriott against Georgia Tech in 1987.

THE DICK CRUM YEARS

MACK BROWN'S
BIG BREAK

1988–1997

MACK BROWN WAS HIRED BY UNC athletics director John Swofford after the 1987 season. An energetic young coach with impressive talent in recruiting quality athletes, Brown came to North Carolina from Tulane, where, in 1987, he had led the Green Wave to its first bowl in 47 years. The Tar Heels posted a dreadful 2-20 mark in 1988 and 1989, but starting in 1990, Carolina enjoyed the first of eight consecutive winning seasons under Brown. The Tar Heels appeared in six straight bowls from 1992 to 1997, while producing a fair share of All-Americans and 1,000-yard running backs. In 1996 and 1997, Carolina won 22 games against only 3 defeats. Brown, unfortunately, was not around for the final win of that run, a 42-3 demolition of Virginia Tech in the 1998 Gator Bowl. He had already accepted the head coaching job at the University of Texas, where he would win a national championship in 2005.

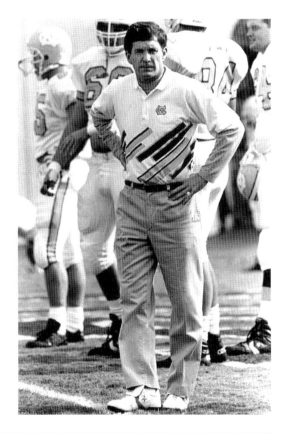

RANDY MARRIOTT (right) led Carolina in receiving in 1987 and 1988, combining to make 70 catches for 1,132 yards and 8 touchdowns. A favorite target of Mark Maye, Marriott caught two of the longest touchdown receptions in school history, a 93-yarder against Georgia Tech in 1987 and an 82-yarder against Duke in 1986. Marriott also holds the record for most receiving yards in a single game with 247.

TAILBACK KENNARD MARTIN WAS one of UNC's primary weapons during Mack Brown's first season as coach. An All-Conference selection in 1988, Martin led the ACC with 1,146 rushing yards. Among his best performances were a 160-yard outing against Louisville, a 177-yard performance against Maryland, and, in the season finale, a whopping 291 yards against Duke, which ranks second for a single game in school history.

MACK BROWN'S BIG BREAK

OFFENSIVE GUARD PAT CROWLEY WAS a mainstay for the Tar Heels in the late 1980s, earning All-ACC honors in 1987, 1988, and 1989. One of only three UNC players to be named All-ACC three times during his college career, Crowley provided running room for two 1,000-yard running backs at Carolina.

CLINT GWALTNEY (NUMBER 17) was one of the most productive place kickers in school history, setting a record with 21 converted field goals during the 1990 season. His longest field goal that year, a 50-yarder, helped Carolina defeat Kentucky 16-13. Gwaltney scored 85 points that fall, the most by any individual Tar Heel in eight seasons, as the Tar Heels posted an overall record of 6-4-1.

THE FOUR INDIVIDUALS IN THIS PHOTOGRAPH, defensive coordinator Carl Torbush (far left), linebackers Dwight Hollier (number 53) and Tommy Thigpen (number 40), and head coach Mack Brown (far right), were among the main reasons for North Carolina's improvement on the gridiron in the early 1990s. Hollier and Thigpen helped the Tar Heel defense improve dramatically in 1990, as the unit gave up 111 fewer points than it did during the 1-10 season of 1989. Hollier was named first-team All-ACC at linebacker, while Thigpen was named to the second team, as the Tar Heels posted a record of 6-4-1. It was the first winning season for North Carolina in four years. The Tar Heels got even better defensively in 1991, giving up fewer average yards to opposition per game than any North Carolina team since 1983.

LINEBACKER DWIGHT HOLLIER (NUMBER 53) was UNC's top defender in Mack Brown's early years as head coach. Hollier led the ACC with 159 tackles in 1989, earning second-team All-ACC honors. The next season, Hollier led the league again in tackles with 155 while claiming a spot on the first-team All-ACC defense.

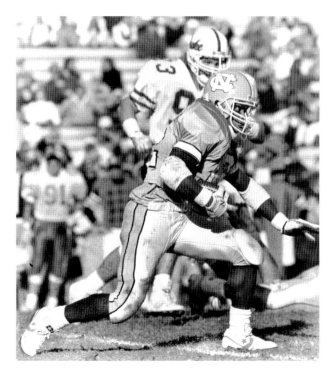

ERIC BLOUNT PRODUCED MORE YARDAGE as a kick returner than anyone in school history. In 1991, Blount had 1,073 return yards, and for his career, he amassed 3,033 return yards; both are school records. Blount led the ACC in punt return average (9.9 yards) as a freshman in 1988, and as a senior in 1991, he led the league in kick return average (27.7 yards).

UNIVERSITY OF NORTH CAROLINA FOOTBALL

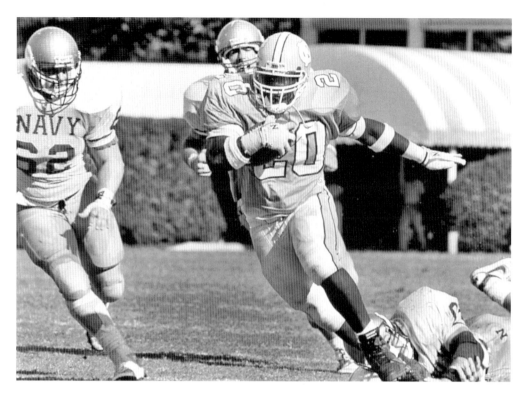

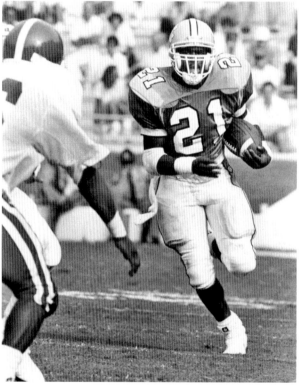

Natrone Means was one of the best running backs in the ACC in the early 1990s, helping the Tar Heels enter the national polls for the first time under Mack Brown. As a sophomore in 1991, Means ran for 1,030 yards, and the following year, as a junior, he rushed for 1,195 yards.

Randy Jordan played at Carolina from 1989 to 1992, where he rushed for 1,134 yards and 9 touchdowns in his career, including 618 yards and 7 touchdowns in 1991. Jordan went on to play a total of nine seasons in the NFL with the Los Angeles/Oakland Raiders and the Jacksonville Jaguars.

MACK BROWN'S BIG BREAK

TOMMY THIGPEN WAS ONE OF the top linebackers in the ACC in the early 1990s, earning second-team All-ACC honors in 1990 and 1992 and first-team honors in 1991. A four-year letter winner, Thigpen served as cocaptain of the 1992 Tar Heels, which finished 9-3 and defeated Mississippi State in the Peach Bowl. Thigpen currently serves as linebackers coach of the UNC football team.

RICK STEINBACHER STARTED 30 GAMES at inside linebacker for Carolina from 1990 to 1993, contributing 307 career tackles. Steinbacher was cocaptain of the Tar Heels and third-team All-ACC during his senior season of 1993. He finished second on the team in tackles in 1992 and 1993. Steinbacher currently serves as assistant athletic director of football operations at the University of North Carolina.

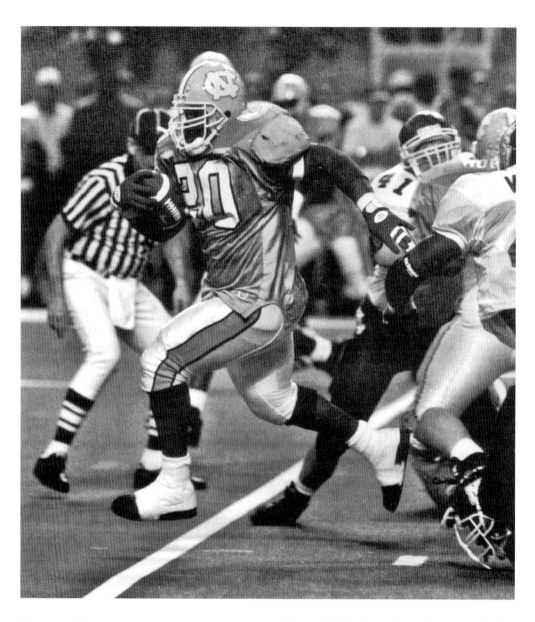

NATRONE MEANS, PICTURED HERE RUNNING the football during the 1993 Peach Bowl, was the primary offensive weapon for Carolina in a season that saw the Tar Heels return to postseason play for the first time since 1986. Means scored a one-yard touchdown in the third quarter of this particular game, which pulled Carolina to within 14-7 against their opponent, Mississippi State. Thanks in large part to Means, who was named the game's offensive MVP after rushing for 128 yards, the Tar Heels were able to come back and claim a 21-17 victory. Means elected to forgo his senior season of college and enter the 1993 NFL draft, and in 1994, he helped lead the San Diego Chargers to a Super Bowl berth. Means played eight seasons of professional football with three different teams, including the Jacksonville Jaguars and Carolina Panthers.

MACK BROWN'S BIG BREAK

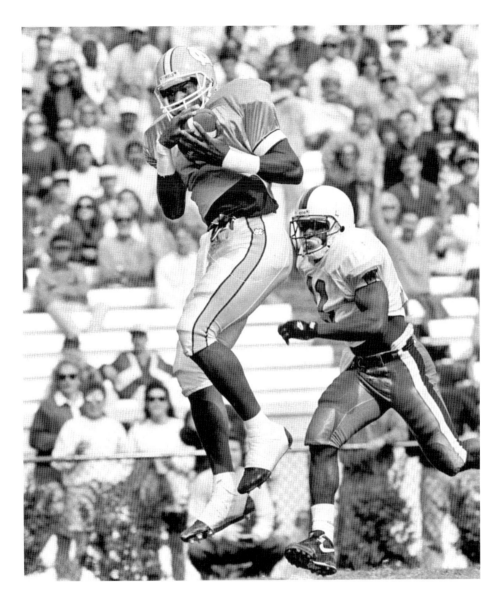

COREY HOLLIDAY, PICTURED HERE CATCHING a pass during Carolina's 27-7 victory over Virginia on October 17, 1992, established a school record with 2,447 receiving yards during his Tar Heel career. From 1990 to 1993, he caught a pass in 45 consecutive games, which established an ACC record. Holliday led the Tar Heels in receiving for four straight seasons, something no player at UNC has done before or since, and was an All-ACC selection in 1991 and 1993. A team cocaptain during his junior and senior seasons of 1992 and 1993, Holliday helped lead the Tar Heels to a Peach Bowl appearance and a Gator Bowl appearance in those years. In his final game at Carolina, the 1993 Gator Bowl against Alabama, Holliday set a school postseason record with nine receptions. Following his playing career, Holliday returned to Chapel Hill, and he currently serves as assistant athletic director for football student-athlete development for the UNC program.

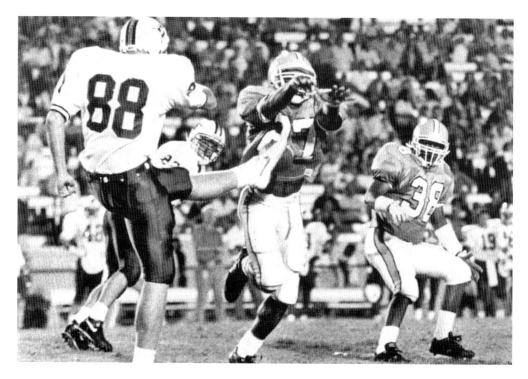

Bracey Walker blocked two punts during Carolina's come-from-behind victory over Mississippi State in the 1993 Peach Bowl, including one in which he returned 41 yards for a touchdown. Walker was named National Special Teams Player of the Year by *Sports Illustrated* in 1993, a season in which he blocked four punts, two of which were recovered for Carolina touchdowns. He has since enjoyed a long career in the NFL.

Jason Stanicek was the commander of the Carolina offense for much of the early 1990s, leading the Tar Heels in total offense for three straight seasons from 1992 to 1994. Stanicek completed 64.1 percent of his passes during the 1993 season, and over the course of his career, Stanicek led North Carolina to 24 wins, which tied Matt Kupec for most victories by a UNC starting quarterback.

CURTIS JOHNSON FILLED IN nicely for the departed Natrone Means as Carolina's featured running back in 1993. Johnson led the team with 1,034 yards to earn first-team All-ACC honors. Averaging six yards a carry over the course of the season, Johnson's finest games that season were against Maryland (168 yards) and North Carolina State (153 yards).

MIKE THOMAS PLAYED AT Carolina from 1992 to 1995 as a quarterback and punter. In his senior season, Thomas set numerous single-season school records, including passing yards (2,436), attempts (332), and completions (185). Thomas also set school postseason records for attempts (39), completions (23), and passing yardage (298) in UNC's defeat by Texas in the 1994 Sun Bowl the year before.

MARCUS WALL, SHOWN HERE DURING his 87-yard kickoff return for a touchdown in UNC's 41-40 victory over Duke in 1994, led the ACC in kickoff return yardage that fall, and his 184 return yards against Clemson set a single-game school record. Wall starred in Carolina's 35-31 defeat by Texas in the 1994 Sun Bowl, making an 8-yard touchdown reception and adding an 82-yard punt return for another score.

IN THIS IMAGE, DEFENSIVE TACKLE Marcus Jones gives chase to a Wake Forest quarterback. In 1995, Jones was named the ACC Defensive Player of the Year, and he was the first Tar Heel player in nine years to be named first-team consensus All-American. Jones capped his UNC career in fine fashion, posting four tackles for a loss in Carolina's 20-10 victory over Arkansas in the 1995 Carquest Bowl.

MACK BROWN'S BIG BREAK

LEON JOHNSON MADE AN IMMEDIATE IMPACT on the Carolina football team during his freshman season of 1993. Teaming up with Curtis Johnson to produce another 1,000-yard tandem in the Tar Heel backfield, Leon rushed for 1,012 yards, to go along with 14 touchdowns, to win ACC Rookie of the Year honors. Although he would never again rush for as many yards in a season as he did his first year, Johnson went on to become the leading all-purpose yardage producer in ACC history, with 5,828 yards. He also established UNC career marks for scoring (306 points) and touchdowns (50). Johnson was the ACC leader in scoring in 1993, punt return average in 1994, and kickoff return average in 1996. In 1995, Johnson rushed for a career-high 195 yards, which also established a new UNC postseason record, in UNC's victory over Arkansas in the Carquest Bowl.

DRE' BLY IS ARGUABLY THE greatest defensive player in the history of Carolina's football program, and unquestionably one of the top defensive backs to ever play in the ACC. Bly entered with a vengeance during his freshman season of 1996, when he led the nation with 11 interceptions, establishing a new school and conference record. Bly became the first freshman in ACC history, and the fifth in history, to be named a first-team All-American by the Associated Press. In 1998, Bly set a new ACC all-time career interceptions record when he picked off his 20th pass. He is the only player in ACC history to be named consensus first-team All-American three times. Bly has gone on to a standout career in the NFL, where he won a Super Bowl with the St. Louis Rams in 2000 and appeared in two Pro Bowls with the Detroit Lions.

MACK BROWN'S BIG BREAK

FREDDIE JONES (NUMBER 92) WAS ONE OF the best tight ends in the ACC in the mid-1990s, earning first-team All-ACC honors following the 1995 and 1996 seasons and third-team All-American honors by Football News in 1996. Jones has gone on to a productive career in the NFL with teams including the San Diego Chargers and Arizona Cardinals.

QUARTERBACK CHRIS KELDORF TRANSFERRED to UNC in time for the 1996 season, and he made an immediate impact. On his way to earning first-team All-ACC honors, Keldorf set new single-season records for completions (201), passing yards (2,347), and touchdowns (23). The following season, Keldorf threw for 290 yards and 3 touchdowns in Carolina's 42-3 thrashing of Virginia Tech in the 1998 Gator Bowl.

GREG ELLIS (NUMBER 87) WAS an elite player on Mack Brown's outstanding defenses of the mid-1990s at Carolina, setting a school record with 32.5 sacks in a career spanning from 1994 to 1997. Ellis was named first-team All-ACC three consecutive seasons from 1995 to 1997, and in 1996 and 1997, he led a defensive unit that ranked second in the nation in total yardage allowed. In those two seasons, Ellis combined to produce 70 quarterback pressures, 36 tackles for loss, and 21 sacks, as the Tar Heels had a combined record of 21-3, which included victories in two Gator Bowls. A first-team consensus All-American in 1997 and a finalist for the Lombardi Award at the end of the season, Ellis was drafted with the eighth overall selection of the 1998 NFL draft by the Dallas Cowboys, where he has played ever since.

BRIAN SIMMONS CAME TO NORTH CAROLINA in 1994 and played on some superb defensive teams during his time in Chapel Hill. An outside linebacker, Simmons had 36 tackles for loss and 11 sacks during his UNC career and was twice named to the Associated Press All-American team; second team in 1996 and first team in 1997. Over his final two seasons of 1996 and 1997, Simmons helped Carolina boast one of the nation's top defenses, which is a big reason why the Tar Heels went 21-3 over that period and won two bowl games. A two-time first-team All-ACC selection, Simmons was a finalist for the Butkus Award, given annually to the nation's top linebacker, following the 1997 season. Simmons was drafted in the first round by Cincinnati in the 1998 NFL draft and has played his entire professional career with the Bengals.

OSCAR DAVENPORT (NUMBER 10) REPLACED THE injured Chris Keldorf as starting quarterback for Carolina during the 1997 Gator Bowl against West Virginia, and he led the Tar Heels to victory, throwing for one touchdown and rushing for another. Davenport completed 14 of 26 passes on the afternoon for 175 yards, earning MVP honors as the Tar Heels prevailed 20-13.

NA BROWN WAS A DEPENDABLE receiver on some of the best teams in school history. Brown caught 55 passes in a season twice (in 1997 and 1998), establishing a UNC record at the time. Brown's most memorable catch came on November 28, 1998, when he hauled in a pass to seal Carolina's 37-34 overtime victory over NC State in Charlotte.

MACK BROWN'S BIG BREAK

JONATHAN LINTON (NUMBER 27) BACKED up Leon Johnson at tailback for three seasons at Carolina before getting his opportunity to start in 1997. Linton made the most of it, becoming the 14th different back in the history of the UNC football program to rush for 1,000 yards in a season. He reached the coveted amount during his 199-yard performance in his final home game, a 50-14 triumph over Duke.

OCTAVUS BARNES CAUGHT 19 TOUCHDOWN passes during his Tar Heel career, more than any other wide receiver. One of Barnes's greatest performances was a 9-reception, 165-yard game against Texas in the 1994 Sun Bowl as a freshman, a year in which he set an ACC record for yardage by a first-year player (609). For his career, Barnes posted 2,398 receiving yards, among the highest in school history.

IN THIS IMAGE, KIVUUSAMA MAYS (number 53), Greg Ellis (number 87), and others attempt to block a kick. In 1997, the Tar Heels boasted one of the finest defenses in school history, ranking number two in the country in total yardage.

VONNIE HOLLIDAY (NUMBER 90) RUSHES THE quarterback during a 1997 game against Virginia. Holliday was named first-team All-ACC at defensive tackle in 1997, a year in which he helped Carolina finish with an 11-1 overall record. A first-round selection of the Green Bay Packers in the 1998 NFL draft, Holliday has spent time with NFL teams including the Kansas City Chiefs and Miami Dolphins.

10

Challenges and Triumphs

1998–2005

Defensive linemen Ebenezer Ekuban (left) and Vonnie Holliday hoist the trophy the Tar Heels have just won after defeating Virginia Tech 42-3 in the 1998 Gator Bowl. The Tar Heels prevailed despite the absence of Mack Brown, who had left before the game to take the head coaching job at Texas. Defensive coordinator Carl Torbush stepped up to the plate and led the team in the Gator Bowl, and from the coach's booth, instead of the field, he guided a nearly flawless execution on behalf of the Tar Heels. The Carolina defense allowed the Hokies only 185 yards of total offense, while holding them to just 90 passing yards. In addition, Tar Heel defenders Dre' Bly and Greg Ellis each scored a touchdown in the game. During the off-season, Torbush was offered the job at Carolina on a permanent basis, and he accepted it.

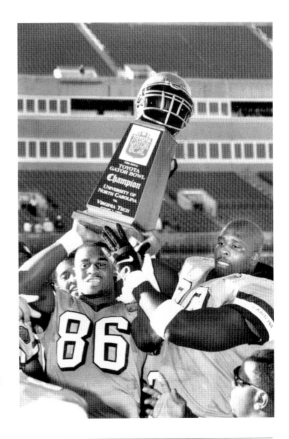

CARL TORBUSH (LEFT) CAME TO North Carolina in 1988 as a member of new head coach Mack Brown's staff, and his ability to mold defensive players left an indelible mark on the Tar Heel football program. As defensive coordinator for 10 seasons, Torbush oversaw a unit that improved dramatically over the years. The UNC defense allowed the second fewest yards in the country during the 1996 and 1997 seasons, a big reason why the Tar Heels finished both years ranked in the Associated Press Top 10. Shortly after Carolina's final regular season game in 1997, Torbush was suddenly promoted to head coach for the 1998 Gator Bowl, and after finding tremendous success in his first game, Torbush was offered the permanent job during the off-season. Torbush led the Tar Heels to a 6-5 regular season record in 1998 and victory in the Las Vegas Bowl, UNC's fourth straight triumph in a postseason game, but a disastrous 1999 season, combined with an underachieving year in 2000, led to Torbush's dismissal after only three full seasons.

CHALLENGES AND TRIUMPHS

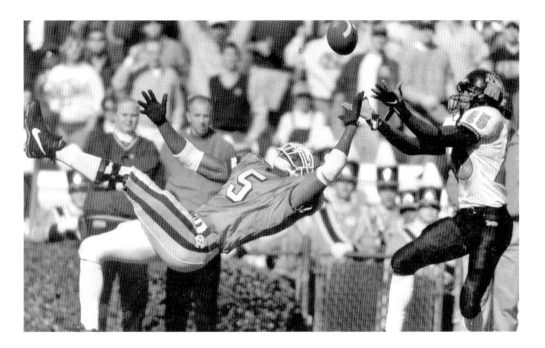

L. C. Stevens (number 5) earned four varsity letters at UNC from 1995 to 1998. One of only a handful of wide receivers in school history to amass 2,000 or more career receiving yards, Stevens made perhaps his biggest play in a Tar Heel uniform as a freshman, hauling in an 87-yard touchdown pass from Mike Thomas in Carolina's 20-10 victory over Arkansas in the 1995 Carquest Bowl.

Ronald Curry was thrown into the starting quarterback role as a true freshman in 1998 and led Carolina to a 7-5 record, which included MVP honors in the Las Vegas Bowl victory. After missing six games in 1999 with an injury, Curry set a school record with 2,676 yards of total offense in 2000. In 2001, Ronald was named MVP of UNC's Peach Bowl victory over Auburn.

TIGHT END ALGE CRUMPLER, SEEN here lifting weights, was named first-team All-ACC in 1999 and 2000 and was a finalist for the John Mackey Award, given to the nation's top tight end, in 2000. A second-round selection of the Atlanta Falcons in the 2001 NFL draft, Crumpler has been a productive player in the professional ranks and, in 2006, was selected to play in the Pro Bowl.

PUNTER BRIAN SCHMITZ SET A new UNC and ACC record during the fall of 1999 by averaging 47.8 yards per punt, earning first-team All-American honors from *The Sporting News*. Schmitz's career average of 44.4 yards per punt is the highest in the history of the ACC.

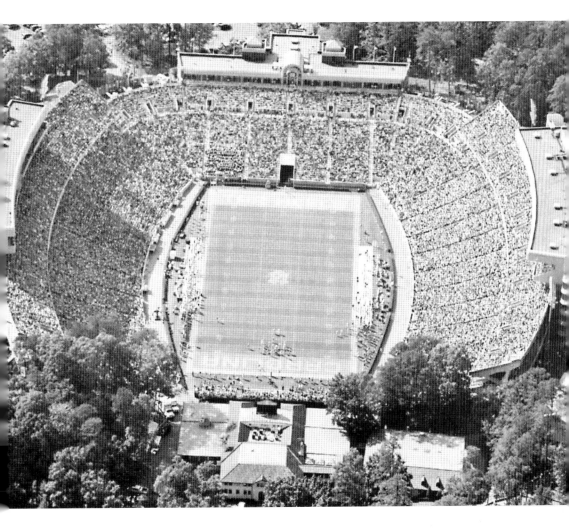

THE HOME OF THE TAR HEELS since 1927, Kenan Stadium underwent a major renovation in the late 1990s, as the addition of the Kenan Football Center in the west end zone, along with an additional 8,000 seats, enclosed the area to give the stadium a "horseshoe" feel. The Kenan Football Center houses the entire Carolina football program, including the weight room, locker room, training room, coaches' offices, and computer/study areas. The expansion increased the stadium's capacity to approximately 60,000. In 2003, a scoreboard with a large video board was placed in the east end zone, adding to the experience of watching a game in the venerable old stadium. One of the most scenic college football stadiums in America, Kenan Stadium has been home to the Tar Heels now for eight decades, and that doesn't look to be changing any time soon.

JOHN BUNTING RETURNED TO HIS alma mater in 2000 to become the head football coach at the University of North Carolina. A former All-ACC linebacker during the Bill Dooley days, Bunting was a year removed from winning a Super Bowl ring as the linebackers coach of the St. Louis Rams. In his first season of 2001, Bunting led the Tar Heels to an 8-5 overall record, including a Peach Bowl victory over Auburn. UNC struggled mightily the next two seasons, posting a 3-9 record in 2002 and a 2-10 mark in 2003, but signs of life returned in 2004. With talk of Bunting being replaced after the season unless things turned around, the Tar Heels came together and finished the regular season with a 6-5 record, including a stunning 31-28 victory over Miami, the school's first-ever triumph over a Top Five opponent. Bunting returns for his sixth season as head coach of the Tar Heels in 2006.

CHALLENGES AND TRIUMPHS

JULIUS PEPPERS
Defensive End
North Carolina

JULIUS PEPPERS WAS A SUPERSTAR at the collegiate level, where he proved to be the best defensive end in the nation for two seasons. As a junior in 2000, Peppers led the nation with 15 sacks, earning All-American honors and the first of two All-ACC selections. He also set a school record that season with 24 tackles for loss. A unanimous first-team All-American in 2001, Peppers won both the Lombardi Award (nation's top lineman) and the Bednarik Award (nation's top overall defensive player), becoming the first Tar Heel player to win either trophy. For his career at Carolina, Peppers accumulated 30.5 sacks and 53 tackles for loss. Peppers was also a major contributor on Tar Heel basketball teams that earned a Final Four berth in 2000 and tied for the ACC regular-season crown in 2001. The second overall selection of the Carolina Panthers in the 2002 NFL draft, Peppers has played in two Pro Bowls thus far in his professional career.

FOLLOWING CAROLINA'S stunning 41-9 victory over Florida State on September 22, 2001, a horde of students and Tar Heel fans converged on the field of Kenan Stadium. In this image, a large number of students have jumped atop one of the goal posts, a college football tradition following a major upset. The students will eventually rip the goal post away and carry it out of Kenan Stadium in triumph.

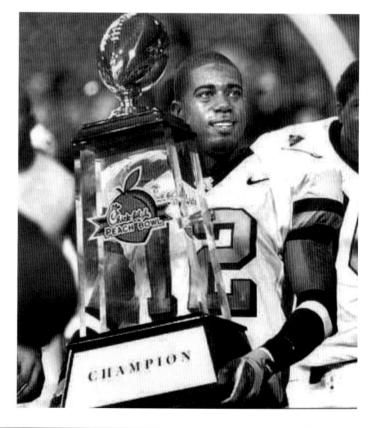

IN THIS IMAGE, KORY Bailey proudly displays the trophy that UNC won following a 16-10 victory over Auburn in the 2001 Peach Bowl. A four-year letterman from 1998 to 2001, Bailey led North Carolina in receiving in 1999. He produced 2,804 all-purpose yards during his career.

CHALLENGES AND TRIUMPHS

RYAN SIMS PLAYED DEFENSIVE TACKLE AT Carolina from 1998 to 2001, earning third-team All-American honors by the Associated Press following the 2001 season. He was also named first-team All-ACC. The sixth overall selection of the 2002 NFL draft by Kansas City, Sims has played in 43 games for the Chiefs heading into the 2006 season.

SAM AIKEN WAS CAROLINA'S PRIMARY RECEIVING option during the 2001 and 2002 seasons, leading the team in yardage both years. In 2002, Aiken established a new school record with 990 receiving yards, coming on 68 receptions. Among his best performances that fall were a 179-yard game against Virginia and a 174-yard output against Miami (Ohio).

DARIAN DURANT IS THE MOST DECORATED quarterback, in terms of offensive production, in the history of the Carolina football program. A four-year starter from 2001 to 2004, Durant finished his UNC career with 51 school records, including career marks for attempts (1,159), completions (701), passing touchdowns (68), passing yards (8,755), and total offense (9,630). The total offense record Durant established shattered the previous mark, set by Ronald Curry, by more than 3,000 yards. In 2002, Durant set a UNC single-game record with 417 passing yards in leading the Tar Heels to a 38-35 victory over Arizona State. Durant was particularly busy during the 2003 season, a year in which he established new school records for attempts (389), completions (234), and passing yards in a season (2,551).

CHALLENGES AND TRIUMPHS

ON AUGUST 30, 2003, A number of former Tar Heels returned to Kenan Stadium for a special ceremony during halftime of the UNC–Florida State game. The university chose to honor several former players, including five first-team All-Americans and two others who had been named among the 50 greatest players in ACC history.

DEXTER REID WAS A HARD-HITTING FREE safety for Carolina who earned first-team All-ACC recognition in 2002. Reid led the Tar Heels that season with 166 tackles, the second highest single-season total in school history. A second-team All-Conference selection in 2003, Reid was a fourth-round pick by the New England Patriots in the 2004 NFL draft.

MICHAEL WADDELL WAS A VALUABLE defensive back and specialist during his time at Carolina. Nicknamed "the Rabbit" for his breathtaking speed, Waddell led the nation in kickoff return average in 2003, averaging 31.7 yards per return. Waddell had a 97-yard kickoff return for a touchdown against Wisconsin that year. In 2001, Waddell returned a punt 89 yards for a score against Oklahoma, the second longest in school history.

JASON BROWN WAS A THREE-YEAR letter winner at Carolina from 2001 to 2003. A standout at center, Brown was named first-team All-ACC and third-team All-American by *Football Weekly* in 2004. Brown was also an Academic All-ACC selection in 2003.

CHALLENGES AND TRIUMPHS

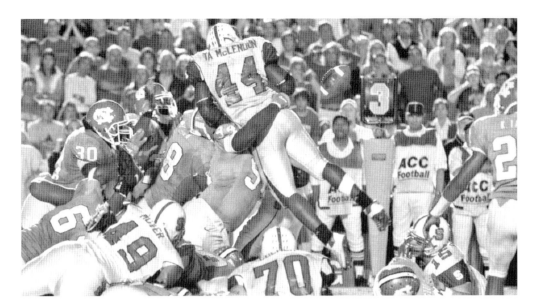

IN THIS IMAGE, TAKEN DURING the Carolina–NC State game in Kenan Stadium in 2004, members of the Tar Heel defensive line stuff Wolfpack tailback T. A. McLendon, forcing him to lose possession of the football. In what turned out to be the game's deciding play, the Tar Heels held out McLendon from the edge of the goal line, preserving a dramatic 30-24 Carolina victory over their rivals from Raleigh.

IN THIS PHOTOGRAPH, CONNOR BARTH (number 10) is in the midst of attempting a 42-yard field goal in the closing moments of the Carolina-Miami game in Kenan Stadium on October 30, 2004. Barth's kick, which sailed through the uprights, broke a 28-28 tie and gave Carolina's football program its first victory in history over an opponent ranked in the Associated Press Top Five.

THIS IMAGE, TAKEN MOMENTS AFTER CAROLINA'S shocking 31-28 victory over the University of Miami on October 30, 2004, captures a wild scene on the field of Kenan Stadium. The video scoreboard, showing the happy final score, is in clear view, and it is easy to see that the assemblage of fans and students have taken over the playing surface. The Tar Heels, behind a career-high 175 rushing yards from Chad Scott, built a 21-14 halftime lead and were able to stay competitive in the second half behind tough defense and an offensive effort that amassed 545 total yards. Scott's second touchdown of the game, coming in the fourth quarter, gave Carolina a 28-21 lead, and following a Miami score in the final three minutes, which tied the game, the Tar Heels drove downfield with a chance to win. As time expired, true freshman Connor Barth converted a 42-yard field goal, which sent the crowd into the euphoric joy that is quite evident in this photograph.

CHALLENGES AND TRIUMPHS

JAWARSKI POLLOCK WAS ONE of Darian Durant's favorite targets during his career at Carolina. In 2003, Pollock established a new school record with 71 receptions to go along with 745 yards and a touchdown. The next season, he added 45 more receptions, which again led the team. In 2005, Pollock surpassed Na Brown to become Carolina's all-time leader in career receptions.

RONNIE MCGILL (NUMBER 25) burst onto the scene for the Tar Heels as a true freshman in 2003, rushing for 244 yards in a 42-34 Carolina victory over Wake Forest. Despite missing much of the 2004 and 2005 seasons with injuries, McGill returns in 2006 with hopes of returning UNC to the postseason.

ACROSS AMERICA, PEOPLE ARE DISCOVERING SOMETHING WONDERFUL. *THEIR HERITAGE.*

Arcadia Publishing is the leading local history publisher in the United States. With more than 3,000 titles in print and hundreds of new titles released every year, Arcadia has extensive specialized experience chronicling the history of communities and celebrating America's hidden stories, bringing to life the people, places, and events from the past. To discover the history of other communities across the nation, please visit:

www.arcadiapublishing.com

Customized search tools allow you to find regional history books about the town where you grew up, the cities where your friends and family live, the town where your parents met, or even that retirement spot you've been dreaming about.